The New Art History

Edited by A.L. Rees and
Frances Borzello

Camden Press

Published in 1986 by
Camden Press Ltd
43, Camden Passage, London N1 8EB, England

Copyright Introduction © A.L. Rees & F. Borzello 1986
The copyright in each of the articles in this volume remains
with the original copyright holder.

Designed by John Maddison

Set in 11/13pt Baskerville
by Windhorse, London E2
and printed and bound by
A. Wheaton & Co. Ltd, Exeter, Devon

British Library CIP Data

The New art history. – (Ideas on art)
I. Art criticism
I. Rees, A.L. II. Borzello, Frances III. Series
701'.1'8 N7475

ISBN 0-948491-07-8

Contents

Introduction

Over the past few years the phrase 'the new art history' has been increasingly heard, above all in history of art departments of universities, art schools and polytechnics, but also in the less academic surroundings of art gallery guided tours, art criticism and art books. When an article analyzes the images of women in paintings rather than the qualities of the brushwork, or when a gallery lecturer ignores the sheen of the Virgin Mary's robe for the Church's use of religious art in the Counter-Reformation, the new art history is casting its shadow. Rather than a tidy description of one trend, the new art history is a capacious and convenient title that sums up the impact of feminist, marxist, structuralist, psychoanalytic, and social-political ideas on a discipline notorious for its conservative taste in art and its orthodoxy in research. The influence of these new ideas has led to some of the most interesting and controversial recent writing about art, a development which this anthology both illustrates and discusses.

The traditional approach to the subject was summed up in Mark Roskill's untroubled book of 1974, *What is Art.History?*. According to Roskill, art history is about style, attributions, dating, authenticity, rarity, reconstruction, the detection of forgery, the rediscovery of forgotten artists and the meanings of pictures. In its serene self-confidence, the book stands out like a beacon illuminating the last days of art history's innocence. In the same year, the shape of things to come was

signalled by T.J. Clark's call in *The Times Literary Supplement* for an art history which took account of the realities of the social world in which art is produced. A year earlier, in 1973, Clark had published two influential studies of French nineteenth-century painting, *The Absolute Bourgeois* and *The Image of the People*, their subtitles, 'artists and politics in France 1848-51' and 'Gustave Courbet and the 1848 Revolution', revealing one of Clark's key interests, the relation between art and class struggle. In 1975 Leeds University began its MA course in the social history of art, under Clark's inspiration. Four years later, the magazine *Block* was founded as a forum for radical historians of art and design. Challenging the polite tones of conventional scholarly exchange, *Block's* remorseless double columns and hard-line language packed a political punch more often found in Nanterre than in the National Gallery. In contrast to the rear-view vision of the art historical machine, which remains fixed on the great dead, *Block* also published photo-essays, collages and articles by living artists or, as it preferred to call them, practitioners. The academics grumbled about jargon, but by 1980 the prestigious Association of Art Historians had opened its conference and journal *Art History* to the new trends, adding to its traditional papers on attributions and influences, new sections on methodology, feminism and social history. By then the new art history was represented among the modules and credits of the Open University, and was beginning to enter the gates of the enclosed kind, too. In November 1985, the journal *History Today* asked six art historians (three of them contributors to this anthology) 'What is the History of Art?'. Nowhere were the words 'new art history' mentioned, but the admissions of doubt and dissatisfaction which mingled with their explanations and defence of their subject revealed a discipline asking itself a number of awkward questions.

When *Block* and its seed-bed Middlesex Polytechnic held a conference in 1982 on 'The New Art History?' – to our knowledge the first public use of the term – they gave the phrase a telling question mark to imply a certain scepticism about its usage. Mark Roskill, too, had placed a query in his

book title, but in his case there was no doubt that he could provide a definite answer. The differences are significant. Roskill's certainties were not so much wrong as limited and uncomplicated. He explained and classified, but he did not question. The new art historians question, giving not only art but the society which enshrines it a long, hard look. They question the status of art, and the almost automatic assumption that art means paintings and sculptures in certain styles. They ask how such objects and not others came to be called 'art' in the first place, and why they alone are worthy of study. Unimpressed by the special claims made for art, they ask what purpose it served for the people who owned it and for those who look at it today in books, stately homes, museums and galleries. Art's subject matter is scrutinized and questions asked as to why the poor, or landscapes, or women look as they do in the 'representations' art makes of them. Art's economic and political role in contemporary society is addressed, in particular the sometimes camouflaged links between scholarship and the market, and the uses made of art by states or corporations anxious to polish up their images. Not even the founding fathers of the discipline escape their severe stare. Fuelled by strong social and political beliefs which they wave like banners above their heads, the new art historians are led by a self-consciousness about their own points of view to question the claims of earlier historians to produce objective scholarship.

Whether or not such upheavals add up to a 'new art history', there are some clear signs of change in the discourse of art history. In discrediting the old art history, words like connoisseurship, quality, style and genius have become taboo, utterable by the new art historians only with scorn or mirth. Such terms, they assert, serve only to obscure a whole (old) world of assumptions about what art is. The presence of the new art history is signalled by a different set of words – ideology, patriarchy, class, methodology, and other terms which betray their origins in the social sciences. Behind them lies a new way of thinking, one which sees art as intimately linked to the society which produces and consumes it, rather than some-

thing mysterious which happens as a result of the artist's genius.

The new art history did not just 'happen' either, a vision revealed to a band of heroic historians to be passed down to their faithful followers. It is a product of the late-sixties tolerance for left-wing and 'continental' ideas which has changed the nature of every academic subject over the last two decades, combined with the expansion of art history as an academic discipline.

The terms for this move were set in 1968 by Perry Anderson, editor of the influential *New Left Review*. His essay, 'Components of the National Culture', argued that British intellectual life had developed without the core of a general theory of society supplied in the rest of Europe by marxism or by classical bourgeois sociology, its 'negative' image. Intellectuals in the British positivist tradition with its fear of general theoretical ideas refused either option in favour of piecemeal, eclectic approaches to their subjects. To redress this weakness, Anderson called for a new radical intelligentsia to challenge the narrowness and conformity of British culture.

The challenge was taken up in the early seventies by the film and media journal *Screen*, which had a widespread impact on the intellectual vanguard by promoting the little-known ideas of the Russian formalists and the Brecht-Benjamin circle, by introducing semiotics from Saussure to Barthes, and by discussing the post-Freudian psychoanalysis of Jacques Lacan. Reacting against the libertarian sixties and its political failure, *Screen* adopted and adapted the structuralist marxism of Louis Althusser and its recondite and determinedly 'rigorous' language. Perhaps ideas so alien to mainstream British culture could only have crept into it through outlying disciplines like film and media studies, which were weak outcrops of English teaching until the radical cineastes of *Screen* showed their relevance to academic enquiry.

By stressing that theorizing was itself a kind of practice which could fundamentally revise the way knowledge was used in society, *Screen* showed that a marxist intelligentsia could come in out of the cold and enjoy respect in the

academic world. For the first time since the thirties, intellec-
tuals were promised a role in British culture instead of merely
enduring it while they awaited the revolution. The range of
new ideas taken from theatre, literature, linguistics and
psychoanalysis to extend the fledgling study of cinema and
TV made *Screen* essential reading for academics in many
fields; its concern for visual representation made it of special
interest to art historians seeking to break their own mould.

But what was the material basis for these intellectual de-
velopments? Art history, like many subjects in the post-
Robbins sixties, was expanding and changing to satisfy new
demands. Although, for many, art history is still associated
with the London-based Courtauld and Warburg Institutes,
elite training-grounds largely built up by German and Au-
strian refugees from Nazism, the subject has other homes and
voices. Art history began to spread after the second world war,
first into the few universities with fine art courses, like Edin-
burgh, Reading and the Slade School of the University of
London, and then more quickly with the opening of the plate
glass universities such as East Anglia, Essex and Sussex. A
further development came elsewhere in higher education
with the introduction of a compulsory 'academic' element into
art and design courses during their sixties expansion, which
put art history into the curriculum for all art students. This
trend continued when the art schools were pushed into the
polytechnic and degree-awarding system during the early
seventies. By the end of the decade, art history's centre of
gravity had shifted from Oxbridge and the Institutes to the
polytechnics and new universities.

This expansion meant jobs for more art historians, many of
them fired by a post-1968 discontent with the mandarin
methods and ideas of Courtauld-style scholarship and
affected by the sixties brand of marxism which had less to do
with revolution than with an analysis of society which saw art
objects as weapons or toys of the ruling classes. Excited by the
battle cries from disciplines already fighting for new ways of
researching and teaching their subjects, aware that students
found art history less stimulating than other subjects on offer

(the sixties saw the start of the fashion for joint or combined degrees), anxious to dispel art history's 'easy option' label and unwilling to assume the old-fashioned mantle of connoisseur of beauty and quality, their ambition, their politics and the tolerant educational climate encouraged art historians to criticize and question.

In its own time, the tradition against which the new art historians pitted themselves had itself been revolutionary. A product of nineteenth-century European rationalism, art history had wrenched art objects from their religious and aristocratic origins to set them firmly in history rather than myth. To protect itself from what it most feared in art – mysticism and idolatry – it took as its task the imposition of order. Art history was founded by Wöllflin and Riegl on the principle that formal analysis of art was the key to its study. In the 1920s, Edgar Wind and Erwin Panofsky led a campaign against formalism, announcing the importance of the cultural and historical context of art. When the 1930s brought the German scholars in their flight from fascism, their zeal for precise knowledge and intellectual seriousness transformed art history in this country from a connoisseur's pursuit into an academic discipline.

When the tradition is given the detailed critique which the accusations of the new art historians seem to demand, it will be seen that it did not concern itself exclusively with high art and genius. Nor was the tradition wholly Eurocentric, since considerable attention was paid to Asiatic, African and Amerindian arts. Even its hostility to theory was mostly directed against Hegel (and, by extension, Marx). Rather than lacking in ideas it could as easily be accused of having too many and those too arcane. And as several contributors point out, a thin red line of historians has always stressed art's relationship to society. Nonetheless, the issues which inspired the new art history's reaction – the tradition's claim to be value-free, its belief in the impartiality of historians, its refusal to admit aesthetics and criticism as part of historical study, its suspicion of theoretical reflection, its obsession with fact-gathering and its blindness to class and gender – are less easy to defend. Such

principles of enquiry no longer meshed with the critical aspirations of the new generation of intellectuals, to whom they spelt sterility and stultification.

At present, the two most distinctive trends in the new art history are the interest in the social aspects of art and the stress on theory. The strand in mainstream art history which tried to place art in its social context began from the art and worked outwards; the new form reverses the procedure, looking from the social fabric to the art it produces. Its central interests lie in an investigation of how the social order is represented and endorsed by art and in the analysis of the institutions of art, including art history itself. The theoretical strand draws on marxist and continental literary theory, psychoanalysis and the critique of patriarchy by the women's movement. Part of its aim is to 'deconstruct' the most familiar and unquestioned ideas, in particular the notion that the work of art is a direct expression of the artist's personality, the belief that art contains eternal truths free of class and time and the conviction that art is somehow 'above' society or out of its reach. Such deconstruction leads to a profound scepticism of the view, expressed, for example, in Kenneth Clark's much admired TV series 'Civilisation', that the work of art is a vessel for individual genius.

When pushed to extremes, both approaches risk overlooking the art they are investigating. Social art history tends to see any claim that art has a special language of its own as a smokescreen for the deeper social reality that supports it. By stripping art of its autonomy, social history is able to regard works of art as illustrations of sexual oppression, class war, imperialism or the ruling ideas of a particular age. But too much stress on the social aspect of art ignores the qualities which make it art rather than something else. A different kind of dissolving is found in the new theory, which defines art as one of the major fictions in the grand fiction of western metaphysics. Since the concept of reality is another of these fictions, an extreme deconstructionist view can lead to a form of nihilism which not only dissolves art but threatens to cut the ground from under the feet of the social historians wh.: base

their studies on historical reality.

The complexity of the new art history's concerns may be due to the fact that the subject is going through two stages at once: questioning its purpose as a discipline and modernizing its tradition through the introduction of new approaches. English went through its self-questioning in the inter-war years, when it was transformed by Leavis and his Cambridge colleagues from a historical to a critical discipline. When English was faced in the early seventies with the theoretical and left-wing ideas which would later reach art history, its awareness that existing critical approaches were not inscribed on stone tablets enabled it to assimilate the developments. The Mac-Cabe tenure episode at Cambridge in 1981 was merely a last resistance from the reactionaries; the war was already over.

Art history's next stage is anyone's guess, though experience suggests some sort of compromise can be expected. A possible direction is supplied by the exhaustive *The Classical Hollywood Cinema* (Bordwell, Staiger and Thompson, London 1985) which unites *Screen*-style theory with traditional historical research. In the light of the influence film studies has had on art history, it is interesting to note that the authors include Gombrich among their intellectual mentors. Radical scholars abroad tend to value Gombrich's writings alongside those of say, Jacques Derrida, an unimaginable comparison in this country where Gombrich is currently seen as tradition personified among radical art historians. Only time will tell, but it may emerge that in some mysterious way, Gombrich has been art history's Leavis. At a more down-to-earth level, the discipline's future could be affected by the current educational cuts in the arts and humanities. Unease at this development is expressed by several contributors.

We had two aims when we invited contributions to this collection. The first was to compile a review of the new developments in art history for the interested but not necessarily specialist reader, since art – indeed all the images which flood a technological society – is of concern to everyone. The second was to let the authors write about their topics in the way they saw fit. The two aims were not automatically compatible. Just

as film studies in the early seventies justified its difficult new language by pointing to the lack of an alternative, many new art historians, particularly those concerned with theory, employ a kind of shorthand for the complicated and often unfamiliar concepts from psychoanalysis, semiotics, philosophy and marxism with which they are dealing. In addition, the rethinking of art, its history and theory, combined with the desire to break openly with the inherited tradition and the fact that much of this discussion has been hitherto confined to specialist journals whose readers are familiar with the concepts employed, can set a barrier between reader and text. Perhaps a transitional period is especially prone to the law of the return of the repressed, so that in resisting old mystiques of art, new ones are made.

While offering an overview of the concerns of the new art history, this anthology does not supply an explanation so much as an examination of the new developments from the point of view which most interests the writers. This explains the variety of positions they hold along the continuum from the old to the new art history, as well as the variety of voices in which they speak. The contributors were invited because they are aware of the new developments in art history, but that does not automatically make them new art historians: several would shrink from the label for reasons which their articles make clear.

Though the views in this collection range from the fervent to the sceptical and from theoretical analysis to an academic version of the 'I was there' account, all contributors share the conviction that the principles and methods of traditional art history must come under scrutiny. There is no party line, and their questions, assertions, doubts and disagreements as they worry away at art and its history – or histories as the new art historians would have it – reveal the active state of the subject. Thanks to them, new areas of art and its history are being held up to the light, to the discipline's enrichment and everyone's interest.

A.L. Rees
Frances Borzello

Reviewing Art History

Dawn Ades

Marcel Duchamp once said that a work of art had a life of about forty years, and after that it became history. An implication of this could be that after a certain period the immediate context that can give a work meaning and immediacy, make it active and offer the possibility of congruence between what the artist thought he was doing and what the public understood the result to be, would have changed beyond recognition. An enormous and complex effort at reconstruction would have to take place, but then it would be history, not art. Matthew Arnold in the nineteenth century took the opposite view in his *Essays in Criticism*, holding that the objective criticism of literature could not take place until sufficient time had elapsed to give a true perspective. (Similiar ideas operated when I was told as a student that I couldn't work on Pollock because he was too 'recent'.) It is a curiosity of our academic disciplines that the study of art is described as history, while the study of literature is not. But the really combative element in Duchamp's remark was the implication that there is no absolute, immutable, timeless and aesthetic value for a work of art outside history.

The assumptions, however, that we have made about his-

tory, that it is (or can be) objective, impartial, scientific and true, have begun to fade. We all know that local (national) versions of events in political history tend to differ. But, as Lévi-Strauss argues, the writing of total history would be impossible; it would present us with chaos. Revolution or war 'resolves itself into a multitude of individual psychic movements. Each of these movements is the translation of unconscious development, and these resolve themselves into cerebral, hormonal or nervous phenomena which themselves have reference to the physical or chemical order'.[1] Faced with the threat of infinite regression, the historian has to abstract; all histories suppress certain phenomena, events, names, dates, ideas, and preserve others. It is a matter therefore of recognizing the level of abstraction involved, of perceiving the myth in our idea of history, recognising that it is always, as Lévi-Strauss says, 'history-for'.

The dominant West has also assumed that its history is the only history, and that other (primitive) people don't have one. Mircea Eliade, the historian of religions and their relations to social hierarchies who studied shamanism in Asia and America, has discussed parallels and differences between ours and other cultures' ideas of history. Parallels have also been drawn between our concept of history as chronology and the concepts of historical time of the Maya and Quechua.[2]

The West has also tended to believe that, like the artist at the peak of Kandinsky's spiritual triangle of mankind, it is necessarily in the vanguard of a constant progress ever onward and upward. So far as the perceived cultural and aesthetic values of other societies are similar to its own, they are judged to be 'civilised' or 'primitive'. The history of art of the last hundred years, no less than other histories, has been selective and partial, in the interests on the whole of a progessive, developmental model, a linear or 'vertical' line from movement to movement, 'ism' to 'ism', in which certain names appear, and others do not. But art historians have begun to develop a critique of this kind of history, and massed their energies in favour of what could be called a 'horizontal' study of an object or range of objects: the conditions under which it was made, for whom,

by whom, how valued, how received and understood, and of a study of what T.J. Clark called 'the more general historical structures and processes'. It is taken that art is not hermetic and autonomous, but bound up with the social and economic movements of its time, as well as conditioned by both artistic tradition and aesthetic ideology.

That such questions have been a concern not just to historians and theorists of art, but to artists themselves, is clear from this quotation from the diary of a founder dadaist, Hugo Ball, written during the First World War from the vantage point of neutral Switzerland:

> We discuss the theories of art of the last few decades, always with reference to the questionable nature of art itself, its complete anarchy, its real relationship with the public, race and contemporary culture. It can probably be said that for us art is not an end in itself – more pure naiveté is necessary for that – but it is an opportunity for true perception and criticism of the time we live... In our debates are a burning search, more blatant every day, for the specific rhythm and the buried face of this age – for its foundation and essence...[3]

But such sentiments and their full implications rarely attract much attention, or even an awareness of what is at stake.

Most historians of twentieth-century art have inserted both Dada and Surrealism into a linear model, with Surrealism in its allotted place between Dada and Abstract Expressionism and roughly parallel, would the structure of a book allow it, to the Bauhaus. In so far as much attention is paid to Dada, it is as a destructive reflex action paired with the positive impulse of Constructivism. The convenience of the 'isms' in this developmental model (it is also one which imposes a particular relationship between Dada and Surrealism) is such that it has seldom been challenged, and can even be seen to have been initiated by the early modernists themselves. In 1925, Arp and El Lissitsky published a book entitled the *Isms of Art*. However, this turns out to be a far from straightforward progenitor; it includes a number of 'isms' that have dropped out of the

histories of modern movements altogether, or which do not fit such classification at all. What degree of irony governed the making of this book, and what were a dadaist and a constructivist doing – artists from apparently opposing 'isms' – collaborating on it?

Surrealism was confirmed as a 'serious' art movement with the 1936 exhibition, 'Fantastic Art, Dada, Surrealism' at the Museum of Modern Art in New York; described as being 'diametrically opposed' to the preceding exhibition in the series, 'Cubism and Abstract Art', it nonetheless served to establish Surrealism within the pattern of art movements by making it the opposing tendency to abstract art, although in the process of smoothing over certain irregularities, others awkwardly poked through. In opposing Surrealism to abstraction, the grounds for comparison were made those of style. But the products of Dada and Surrealism are so heterogeneous as to preclude any definition built on style. However, if Surrealism was to maintain its position within the 'history of modern art' this could not be admitted, and in 1968 Rubin wrote in the catalogue of the Museum of Modern Art exhibition 'Dada, Surrealism and their Heritage':

Dada and Surrealism... fostered activities in the plastic arts so varied as almost to preclude the use of the terms as definitions of style. 'Impressionism' and 'Cubism' designated particular painting styles that already existed; the terms 'dada' and 'surrealism' pre-existed the art to which they were applied. Obviously a definition of style that, for Dada, must comprehend the work of Duchamp and of Arp, and, for Surrealism, that of Miró and Dalí, will be problematic. Yet the alternative is not simply to accept confusion. We can distinguish in Dada and Surrealist art some common properties of style, and many comon denominators of character, iconography and intent.

Apart from the fact that it is not quite accurate to say that the terms Dada and Surrealism pre-existed the art to which they were applied, this statement is clearly struggling with a problem that is intractable because of the impossibility of trying to make these terms define a style.

It is necessary to re-examine these terms from a different standpoint. They have, first of all, considerably more justification in themselves than Cubism or Impressionism, given that they were chosen by and defined by the writers and artists concerned. But they are used too often as tokens, either in general histories of art or of individual artists, or in more general theories of art and culture. Dada, for instance, is seen as contributing to the 'negative cast' of modernism, and this alone becomes its token value. Not only does this token categorization simplify to the point of caricature, it also narrows the context for specific works of art or specific artist's practices and distorts the nature and extent of the involvement of Dada and Surrealism in the visual arts as a whole.

To try to explain in more detail what I mean, I would like to look at what happens if close attention is paid to the periodicals published by Dada and Surrealism during their active lives between 1916 and 1939. These periodicals, I suggest, constitute in a real sense the life of each movement, in that they contain different voices. Obviously the manifestos are also important, but it is when they are read in the context of the reviews that their implications are clearest. The reviews are sites of debate, confrontation, experiment and creation.

Dada has been readily characterized as negative, ephemeral and inconsequential. If we study the reviews, (and they proliferated between 1916 and 1924, in different places and different languages), it is clear that the negative and aggressive were only part of Dada's strategy, but one which served its immediate opponents and subsequent historians all too well. Though Walter Benjamin recognized Dada's impulse towards the new art form of film, he refused to allow that its poetry was other than 'word salad'. However, Tzara's 'Dada Manifesto 1918', printed in the issue of *Dada, no.3* (the first to make typography itself an active factor), embeds in its parody of the Hegelian dialectic an appeal for a new art based on a set of less egocentric and 'idealized' values. And in the reviews we find also explorations of the ancient dichotomy between word and image, the beginnings of photomontage and automatic writing. There is in Dada both a focus on the medium itself, which

would have to be considered in relation to modernism as a whole, and, in photomontage, the roots of a political art which Heartfield was to exploit. To try to forge a single definition of Dada in terms of style is clearly inappropriate, simply in terms of the material itself. It could seem as if I am appealing to the 'myth of originality', but I am just pointing to the inadequacy of a reading of Dada as purely negative.

As far as Surrealism is concerned, there were three major reviews in succession, official 'organs' of the movement between 1924 and 1939, plus others of which Bataille's *Documents* was the most important. This welcomed dissident surrealists during its short life (1929-30), and constituted a kind of internal attack on Surrealism. As well as the generally recognized fact that Surrealism was engaged in many other fields than art, the reviews also show that the visual arts were a focus for debate. The nature of the visual material in the reviews, the manner of its presentation and its relation to texts, all bear importantly on this debate. In terms of the interrelations between art and literature, language and visual representation, the reviews again provide a primary site of enquiry. It is impossible, in fact, to understand much of surrealist art in isolation from surrealist writing and surrealist poetic discourse.

The surrealist interest in Freud and psychoanalysis, fully attested, of course, by the first *Surrealist Manifesto* by Breton, continues not wholly uncritically in the reviews, and through voices other than Breton's. It was sufficiently serious for the surrealist review of the period, *Minotaure*, to publish some of the earliest writings by Jacques Lacan.

We could take one example of the way attention to the reviews may demonstrate the intersection of a particular painting with a current debate. Dalí's *Le Jeu Lugubre* was painted in the summer of 1929 when he was on the verge of officially joining the surrealist movement. But there is more than one context for it. A schematic drawing of it was published by Bataille in *Documents*, together with a text in which Bataille proffers a brutal psychoanalytical reading of it, and also mocks the surrealists for misunderstanding it. Dalí would not allow a reproduction of the painting in *Documents*, but

surprisingly it was not one of the two pictures in *La Revolution Surréaliste* in December 1929. Questions might then be raised as to why this painting should serve as a point of confrontation between Bataille and Breton, and how far the reading of it by each was substantially different.

A further, crucial element in these reviews is the introduction of objects from 'alien' cultures – particularly from Oceania and the Americas. Because Surrealism itself is not a definition of style, these objects were not introduced because of their striking formal qualities, as they might have been in a cubist review, but because of a larger interest in the society from which they came. But there is no attempt to integrate them. This tendency is seen most forcefully in *Documents*. To take issue no.4, September 1929: placed together are articles on the American Indian use of scales, Seurat drawings, Cycladic sculpture, the human face, Seghers' engravings, Giacometti, and reviews of Lew Leslie's Blackbirds, jazz, Dalí and Buñuel's recent film *Un Chien Andalou*. Mixing ancient and modern and the popular with the fine arts was not so new, but to introduce ethnography and a kind of sociology was. By adopting the principle of collage, isolating, mixing and juxtaposing without attempting to unify or homogenize, the sheer strangeness and incongruity stands. The effect is to challenge the idea that there can be a unifying concept of mankind; it challenges our ethnocentric view of civilisation and places the familiar continually under attack. 'The surrealist moment in ethnography', as James Clifford writes, 'is that moment in which the possibility of comparison exists in unmediated tension with sheer incongruity'.[4]

Although I have been trying to argue the case for the close study of a particular group of reviews (not, or course, to the exclusion of other materials) in a frankly partial manner, I think similar cases could be made for others, both as contexts for a given artist, writer or critic and as things in their own right.

The refusal to smooth over incongruities, to provide clear contexts for comparison (is it anthropology? aesthetics? comparative religion? history of art and ideas?), and furthermore

the refusal on the whole to soften the real disagreements, not to speak of contradictions, in the writings of the contributors to these reviews, provides a number of problems for art historians. It could be suggested, as Pontalis did in his preface to Xavière Gauthier's *Surrealism et Sexualité*, that it was precisely Surrealism's efficacity to have maintained a series of contradictions *without* resolution. But this is uncomfortable for a discipline which tends to work towards a unified view of individuals and movements, and to bestow value on them according to the measure of their unity. Surrealism has not on the whole been well understood, and the same could be argued for other 'movements', individuals and specific works which defy a monolithic reading.

I am not proposing this as in any sense an exclusive method, but suggesting a starting point for enquiry.

Notes

1 Claude Lévi-Strauss, *The Savage Mind,* 1966, p.257.
2 See Richard Luxton, 'The Hidden Continent of the Maya and the Quechua', unpublished PhD thesis, University of Essex 1977.
3 Hugo Ball, *Flight Out Of Time*, NY 1974, p.58.
4 James Clifford, 'On Ethnographic Surrealism', *Comparative Studies in Society and History*, October 1981.

How Revolutionary is the New Art History?

Stephen Bann

Harold Rosenberg once wrote in his essay on 'Revolution and the Concept of Beauty' that: 'Revolution in art lies not in the will to destroy but in the revelation of what is already destroyed. Art kills only the dead.'[1] As he puts it, 'the *decision to be revolutionary* usually counts for very little' in the province of the arts. 'The artist who engages himself with angels or stained glass windows may produce innovation as devastating as the designer of a new cosmos in plexiglass.' It may seem blindingly obvious to make a similar point in connection with the practice of art history. But I will make it nonetheless. There is no reason to suppose that a 'revolutionary' practice of art history has emerged, or indeed could emerge, because a significant number of art historians are committing themselves to new social movements and radical causes. This commitment would be, at the most, a symptomatic sign of what is already taking place at another level, and for quite different reasons. In company with Rosenberg, I would argue that a revolutionary, or indeed a 'new', cultural critique derives its potency from the fact that the 'old' positions are already bankrupt. Art history, in other words, kills only the dead.

My first task in answering the question must therefore be

one of analysis and dissection. Before deciding upon the equation of the 'new' and the 'revolutionary', it is important to frame the issue in a more fundamental way. Is there a 'traditional' art history, and is it dead? On the surface, at any rate, the response to this conundrum could be made without equivocation, and with a certain amount of truculent impatience for its tendentious nature. Judged by a whole number of reliable indices, art history in Britain (for it is worth starting on the home patch) has never been more flourishing. It is well entrenched in secondary and higher education where (in comparison with, say, the modern languages) its buoyancy and appeal at all levels appear to be beyond dispute. Within the range of the arts or humanities subjects, it occupies an enviable place – just close enough in method and nomenclature to be aligned with the 'traditional' subjects, and yet at the same time tinged with glamour of more recent and more peripheral recruits to the team, like drama and film studies. I will take this point for granted, since it would be tedious and irrelevant to argue it at length. Suffice it to say that art history in Britain has outgrown the stage when it was confined almost exclusively to postgraduate studies at specialized institutes, and has been disseminated throughout the educational system. As I write this on the day when yet another record price for an old master has been recorded by a British auction house, I can hardly forbear to point out that the prestige of art history in this country is inextricably linked with the prestige attaching to our entrepreneurial skills in the art market, and of course to the great museums and galleries which, in many respects, stand midway between the academic and commercial worlds.

All this has to be said. But of course it does not really deal with the issue of whether there is, in fact, a 'traditional' art history, and whether it is bankrupt. Perhaps the difficulty is compounded by the uncomfortable truth that subject barriers and subject identity within the arts have, in any case, been established comparatively recently in Britain, with History only emancipating itself from the iron embrace of Law in the later nineteenth century, and English only showing itself

worthy to inherit the mantle of Classics within the last sixty years. But art history has a more radical instability than either of these disciplines. If I were an enquiring Martian trying to discover by empirical investigation the parameters of contemporary art history in Britain, I would obviously take the short cut of examining the works of two of the most honoured members of the profession: say, Sir Ernst Gombrich and Sir Lawrence Gowing. As a result of surveying Gombrich's magisterial works, I would come to the conclusion that the art historian must be a very well educated person indeed; he should, at the very least, be familiar with the German philosophical tradition (and with the objections raised to it within the same family of discourse), just as he (or she) should be aware of the latest advances in perceptual psychology, and other experimental sciences bearing upon the problems of cognition. As a result of reading Gowing's works, I would come to a rather different conclusion. It would be clear that, though the author does not actually repeat Alberti's statement of intention – *parlo come pittore* (I speak as a painter) – he sees it as by no means irrelevant that he is a practising painter as well as an art historian; that he is particularly conscious of the capacity (and incapacity) of language to represent the nuances of painterly practice; and that he views the essential challenge as being one of recreating and interpreting the experience of seeing a work of art, whether it is as historically remote from us as the paintings of Vermeer, or as contemporary as the work of Lucian Freud. A reader of Gombrich might be directed, quite rapidly, to Hegel. A reader of Gowing might profit by looking at Adrian Stokes.

I can anticipate an objection to this choice of Gombrich and Gowing as exemplary art historians. It might be argued that Gowing is, by choice, a peripheral member of the profession, whilst Gombrich has converted the admittedly diverse cultural sources of his approach into a coherent method which is now, undividedly, 'art-historical'. But anyone who argues in this fashion is not going to be let off the hook so easily. Gowing raises in a very direct way the relation of art history to painterly and writerly practice, and of course he also raises the ques-

tion of the duty of the art historian, as critic, to contemporary art. If these seem to be peripheral issues in the British context, then this is not necessarily something to boast about. One only has to look at the matter from the point of view of a French art historian (who would probably be familiar with Gowing's work, and certainly familiar with the issues which it raises), or a contemporary British artist, to see how restricted a position is being maintained. I once witnessed the painter Howard Hodgkin politely upbraiding a plenary session of British art historians for paying so little attention to contemporary work. I doubt whether he made any converts. But it still remains an odd anomaly that, whereas for literature the title of 'critic' is not disavowed by the most illustrious of professors, the academic exponent of art history would hardly feel comfortable with the title and practice of an 'art critic'.

As far as Gombrich's method and example are concerned, the response to the dismissive argument must be a very different one. It can hardly be denied that Gombrich's works have a central position in any British art historical tradition worthy of the name; clearly no one has even approached his stature both as a popular mentor and as an inexhaustibly fertile source of new readings and new interpretations of the most diverse materials. But it is to be regretted that Gombrich's plurality of concerns has not been passed on, with the occasional rare exception such as Michael Baxandall, to his successors in the next generation. Indeed British art historians of the middle generation have conspicuously failed to recognize that the greatest compliment to be paid to Gombrich would be to treat his theories with the seriousness which they deserve, and to examine their ideological and philosophical basis. When Norman Bryson devises the syntagm 'Pliny – Vasari – Gombrich' to account for the persistence of the realist notion of the 'essential copy', he is in effect doing just that.[2] No amount of expostulation from art historians who argue (doubtless rightly) that art history is perpetually revising and refining its methods in a piecemeal fashion will obviate this fact. Bryson wants to make a wholesale revision of the assumptions on which (in his view) the Western pictorial tradition is

based, and in order to do so, he must attempt to 'place' Gombrich in a context which incorporates the central theoretical expressions of Western pictorial practice.

Let me make it clear at this stage what precise argument I am pursuing. I began by making the fairly obvious point that the 'revolutionary' nature of a 'new art history' could only be substantiated with reference to some notion of traditional art-historical practice. Yet it is not easy to give such a definition, partly because of the youth of the discipline, and partly because it covers such a wide spectrum of possible approaches. If anyone objects to my citation of Gombrich and Gowing as evidence of this breadth, I can only suggest that they try and provide their own definition of normative art history, and examine its relation to the unquestionably important issues raised by Gombrich and Gowing. I suspect that they will find that such a normative art history has been characterized in particular by a refusal to raise, on any level of seriousness, the very issues which preoccupied the earlier generation. One of the reasons why Bryson's series of studies has aroused such intense and varied reactions, ranging from contemptuous dismissal through polite puzzlement to ludicrous misapprehension, is that he challenges this tendency to theoretical quietism.[3] What is more, he does it from a vantage point which is, at any rate in strictly institutional terms, outside the art-historical community. He raises the spectre of an expropriation of art-historical territory by the Great Powers of literary and linguistic studies.

Yet to advance this argument is to move too quickly on to the domain of institutional polemics. What is more worthwhile is to examine a little more closely the internal dynamics of art history, as it is practised in Britain and in the Western world in general. It is obviously outside the scope of this brief article to give more than a glimpse of such a varied and lively scene. But I can try to do this, in miniature as it were, by evoking the rather fascinating spectacle of the conference on Dutch seventeenth-century painting, which was beneficently organised by the Royal Academy in November 1984, to mark the occasion of its magnificent show, 'The Age of Vermeer

and De Hooch'. This was a conference at which scholars of several generations, not all of them art historians, contributed papers on numerous aspects of Dutch art and society during the period, before an audience which included a large number of the foremost art historians. It was a conference which (in my view) generated as much frustration as it did enlightenment, ultimately because it showed this representative group to be in a state of some disarray as regards method, and the theoretical assumptions underlying method. It was a conference at which both Gombrich and Gowing expressed themselves firmly and categorically, with Gowing calling for a six-month moratorium on the use of emblem books, and Gombrich stating as his valedictory judgment: 'Lessing, thou should'st be living at this hour'.

What then constrained Gowing to excoriate the emblem books, and Gombrich to appropriate Wordsworth's *Sonnet on Milton*? The answers to these questions are, I believe, instructive. As far as emblems go, it is not so very long since these ingenious combinations of word and image, popular in Europe from the sixteenth century onwards, were regarded as beneath serious attention. In his *Studies in Seventeenth-Century Imagery*, published in 1964, Mario Praz had to put the question: '.... are emblems really such dead things?'. I can recall trying to discover some commentary on the elaborate emblem scheme of the west doors of the Cathedral of Pisa, only to find that John Pope-Hennessy's standard work completely neglected the significance of the emblems, being confined to a discussion of whether or not the doors were of 'provincial' workmanship.[4] However the tide has unquestionably turned in the last few years (prompted among other things by Gombrich's essay in *Symbolic Images*). It appears that nowadays the emblem books are systematically ransacked, not only for their own sake, but to provide a key for the otherwise enigmatic configurations of elements which we find in many of the Dutch genre paintings of the seventeenth century. It was impossible to deny that some of the contributions to the Academy conference proceeded on this basic assumption: that Dutch genre painting could be interpreted simply by con-

sulting the extensive repertoire of identified symbols and didactic verses which the emblem books afford. A painting could be metamorphosed by such research into a little parable of the virtues of industry, or the dire effects of sloth.

Hence Gowing's call for a moratorium – and Gombrich's invocation of Lessing. Gowing, the author of a fine study of Vermeer, could not tolerate such a complete disregard for the existential act of painting (and the existential effect of looking at the result of such painting, which is indisputably different from the experience of studying an emblem book). Gombrich invoked the German writer whose treatise, *Laocoon*, revised the traditional custom of discussing paintings and poetry in identical terms (*ut pictura poesis*), and postulated quite different aesthetic conditions for the understanding of the arts of time and the arts of space. These two brief interventions were, however, rendered more piquant by the fact that the author of the most thought-provoking recent study of Dutch seventeenth-century painting was not present at the conference. The American art historian Svetlana Alpers, author of *The Art of Describing*, was not able to lend her voice to this debate. But she was able to review the issues in an exemplary article for the *London Review of Books* which appeared shortly afterwards.[5] Here, at last, was a temperate and well-informed discussion of the theoretical questions which had simmered, to little effect, at the conference. Since her attitude coincides closely with what I shall characterize as the 'new art history' for the purposes of this article, I shall pay some detailed attention to it.

Svetlana Alpers has comparatively little time for the emblematic interpretation of Dutch painting in its simple and banal form ('The viewer who admires the sheen on a Ter Borch gown is now told that the woman is a whore being sought or bought before our eyes, women looking at mirrors are sinfully vain, and Vermeer's woman by the window reading is engaged in extra – or pre-marital sex. Merry drinkers are gluttons. And so on.') She has hardly more time for what she takes to be the succeeding fashion of interpretation: the catalogue of the Academy exhibition suggests a movement

from moralistic cliché to social and cultural valuation ('Ostade's peasants are not warning us off violence, drink or lust, but are showing us how the superior classes viewed those way below them. Far from cautioning men and women against seduction, Ter Borch's paintings are an instance of the maintenance of social decorum among the better classes.') Both of these approaches deflect attention from what, in her view, is the irreducible property of Dutch seventeenth-century paintings, which exists prior to any interpretation in moralistic and cultural terms. This is quite simply the visual effect of the paintings – a consideration slightingly dismissed by the catalogue as amounting to 'nineteenth-century art for art's sake', but in fact no less intimately rooted in the seventeenth century than the structures of class and the codes of social decorum: 'What characterizes the visual culture of the seventeenth century is a belief that reality is not given but has to be found out through what was considered to be the investigative craft of seeing – of which painting itself is an exponent.'

I take this to be the basic theoretical contention of the article (and I will forego, for reasons of space, the many fascinating examples of specific interpretation to which it leads, both here and, much more extensively, in *The Art of Describing*). Svetlana Alpers draws our attention to the aspect which was strangely excluded from the Academy conference: that is, the representational status of these images. It seems to me an undubitable fact that art historians are, in general, dismissive of the questions of representation. Museums like the National Gallery play their part in conserving the occasional piece of apparatus, like Van Hoogstraaten's viewing box, which draws attention to the precise mode of visual representation being used to establish an illusion. But such a 'peepshow' is liable to be devalued, or seen as a childish diversion, beside the more serious work of historical and cultural evaluation. And of course, if the peepshow is seen in isolation, it becomes simply the operator of a particular kind of visual effect (hardly a very remarkable one in the age of television and holography). The important move consists in relating this kind of evidence, and of course that of

the paintings themselves, to what Svetlana Alpers here de-
scribes as the 'investigative craft of seeing' (and what Michael
Baxandall, in the Renaissance context, identifies as the 'cogni-
tive style' of an epoch).[6] Only through making the assumption
that there is indeed a 'craft' of seeing, constituted historically
in the dialectic between internal experience and the external
forms of representation, can we begin to make sense of the
unique Western tradition of visuality.

There are a number of reasons why art historians, for the
most part, fight shy of this type of commitment. One reason is
that they can see, quite understandably, a possible blurring of
the lines of demarcation between their own province, and
those not far removed from it. The art historian who borrows
a historical method from the general historian – to facilitate a
study of patronage, or to fix the image of the soldier in
seventeenth-century Holland – is not foregoing the prior
right to a certain kind of *object*. It is with these objects – paint-
ings, drawings, sculpture, architecture and so on – that their
professional expertise is engaged. But what about a 'craft of
seeing' – of which painting is 'an exponent' (along with the
microscope and the map)? Perhaps the art historian has no
special right to talk about that. Indeed the very enterprise
seems to call for a new interdisciplinary synthesis, in which
historians, philosophers, literary scholars and anthropologists
can also play their part. That this is not merely a pipe-dream is
demonstrated effectively by the emergence in the last two
years of the outstanding new journal *Representations*, edited by
Svetlana Alpers and Stephen Greenblatt.[7] *Representations* ex-
ists 'to encourage a new community of scholarship among all
who explore the way artefacts, institutions, and modes of
thought give a heightened account of the social, cultural and
historical situations in which they arise.' It is therefore not by
any means confined to visual materials. But of that 'height-
ened account', images as various as Medusa's head, Uccello's
representations of war, and the narrative adornments of
Chinese pictorial vessels, can offer a powerful example.

Here, it seems to me, the destiny of the 'new art history' is
integrally bound up with what has come to be called the New

History. Returning to the discussion with which I opened this article, I would want to ask if there is indeed a New History which is beginning to emerge, Phoenix-like, from the self-immolation of the Old. I may be accused of a feverish imagination, but it does indeed seem to me that such a prodigy may be taking place (and the existence of *Representations* would be one of its major signs, in the Anglo-American context). The solid work of the *Annales* school, culminating in the achievement of Braudel, Duby, Le Roy Ladurie and so on, is complemented by the emphasis of an American historian like Natalie Zemon Davis, and a British historian like Keith Thomas. It may no longer be regarded as taboo for a historian to have a self-critical estimate of the rhetorical underpinning of the historical craft, such as might be obtained from reading Foucault, or Barthes, or Hayden White. This is a necessarily hasty evocation. But the point which I am making is surely clear. There can be no 'new art history', revolutionary or not, except to the extent that it participates in a 'new history'. And even if the signs are that the new (art) history will cause a blurring of demarcations, and a migration to rather different territory, this should be seen as an opportunity and not a catastrophe. After all, the art historian is no less qualified than anyone else to take part in such an enterprise. What must be abandoned is simply the debilitating assumption that a strict archival method, coupled with an interpretative *open sesame* which enables us to convert paintings into moral, social or political texts, will reveal to us all that needs to be known about visual representation.

Let me finally add that there seems to me to be another strategy worth identifying, which runs parallel to the interdisciplinary emphasis of a journal like *Representations*. If the art historian cannot really establish and defend a method on the basis of a prior right to a certain kind of object, it is nonetheless true that increasingly fruitful work has been done over the last few years on what might be called 'mixed objects'. Two obvious examples would be the garden and the museum. It goes without saying that both gardens and museums are integrally related to the historical development of other visual forms.

Yet, in order to study them, one requires a diversity of new concepts and techniques – of the sort developed by the contributors to a journal like the *Journal of Garden History* (I might also add the example of my own recently published study, *The Clothing of Clio*, which attempts to put the evolution of museum types in nineteenth-century Europe in the context of the general development of ways of representing the past).[8] Once again, it would be erroneous to classify these pursuits as 'new art history', except in the sense that they repudiate, by their very nature, all the assumptions of a positivist, exclusively defined art-historical stance. They also seem particularly conducive to the importation of critical methods derived from linguistics, such as semiotics and semiology. Yet another new journal, *Word & Image* (edited like the *Journal of Garden History* by John Dixon Hunt), balances itself strategically at the dividing line between images and words; any conceptual problem or class of materials which overrides this line is a potential subject for a special number.[9] However wide its terms of reference, this type of journal seems to me to be an excellent augury for the new art history. For without predetermining the important issues of method, it stakes its future on the assumption that new questions and new areas or research will continue to burgeon precisely at those points where the study of the image converges with the study of language. Perhaps it is putting it a bit strongly to call this type of commitment 'revolutionary'. It cannot be denied, however, that the main emphasis of Western academic study has tended, over the last century at any rate, to keep the two areas of investigation strictly apart. Like the new disciplines which take as their subject matter film and photography, the new art history is destined to play its part in raising this taboo.

Notes

1 Harold Rosenberg. *The Tradition of the New,* London 1962, p.76.

2 Cf. Norman Bryson, *Tradition and Desire – From David to Delacroix,* Cambridge 1984, pp. 7-18. Also by the same author, *Word and Image – French Painting of the Ancien Regime,* Cambridge 1981, pp.1-28; *Vision and Painting,* London 1983, esp. chs. I and II.

3 For an example of dismissal, see Nicholas Penny, 'The Great Business', in *London Review of Books,* vol.7 no.5, 21 March 1985, pp.12-14. Penny implies that it is self-evidently absurd for someone to write about painting as Bryson does, and that such a critical style can only be 'intended for initiates' – to which one can only reply: why not become an initiate? For an example of misapprehension, see the lengthy review of the same book by Lorenz Eisner (*Times Literary Supplement,* 12 April 1985). Inextricable confusion is caused by the fact that, for Eisner, Bryson seems to have invented his whole critical apparatus *ex nihilo* (whereas, in reality, much of the book's persuasiveness resides in the careful and inventive way in which Bryson transfers and explores Harold Bloom's well-known concept of influence). Once again, the question arises: are art historians professionally bound to remain ignorant?

4 Cf. my paper, 'Le sérieux de l'emblème', in Jean-Marie Benoist, (ed.), *Figures du Baroque,* Paris 1983, esp. pp.116-118. Gombrich's essay, 'Icones symbolicae', is included in *Symbolic Images,* London 1972, pp.123-91.

5 Svetlana Alpers, in *London Review of Books,* vol.6 no.21, 15 November 1984, pp.21-22

6 Cf. Michael Baxandall, *Painting and Experience in Fifteenth Century Italy,* Oxford 1974, esp. pp.36-40.

7 *Representations* began publication in 1983; at the time of writing, the most recent number was No.8 (Fall, 1984). Individual subscriptions for each year (four issues) cost $20, including postage, and are obtainable from University of

California Press, Periodicals Department, Berkeley, CA 94720, USA.

8 Stephen Bann, *The Clothing of Clio – A Study of the representation of history in nineteenth-century Britain and France*, Cambridge 1984 (esp. chs. III, IV, V).

9 *Word & Image* began publication in 1985, the first issue being on the theme *ut pictura poesis* and the second on 'Painting as Sign'. Individual subscriptions for each year cost £20, including postage, for four issues, and are obtainable from Taylor & Francis Ltd., Rankine Road, Basingstoke, RG24 OPR.

On Newness, Art and History:
Reviewing *Block* 1979–1985

Jon Bird

'It is instructive to glance at the case of art history, which, never having really broken with the tradition of the amateur, gives free rein to celebrating contemplation and finds in the sacred character of its object every pretext for a hagiographic hermeneutics superbly indifferent to the question of the social conditions in which works are produced and circulate...'

Pierre Bourdieu[1]

Inevitably, reflecting upon the history of a particular intellectual project can produce a tendency to ascribe a coherence and a unity to what, at the time, was a fairly loosely formulated set of intentions and objectives. The constraints operating upon the production of discourse outlined by Michel Foucault – 'in any society the production of discourse is at once controlled, organized, selected and redistributed according to a number of procedures' – apply equally to the historical project of reconstruction. Bearing this in mind, then, the initial stimulus behind the journal *Block* was a desire to intervene, (and how elastic and diminished that once politically aggressive term has become), in the discourses dominating the interpretation and validation of visual culture.[2] Thus the editorial for the first issue announced our intention to 'address the problems of the social, economic and ideological dimensions of the arts

in societies past and present', an aim which has remained fairly constant over six years of publication. However, for the purposes of this essay, and given the expressed aim of the anthology, I will concentrate mainly upon the theoretical influences determining our approach, (and, hopefully, contribution), to art-historical and critical discourses, with the reservation that that initial and iconoclastic endeavour seems to have become identified with a recent academicism characterized as 'the new art history'.[3]

At the outset the context of an educational insititution (Middlesex Polytechnic) provided both the academic experience and collaborative practice that allowed the possibility of a publication to emerge. The planning and operation of art and design history courses, a new cultural studies and MA design history degree, and the actual means of production for printed matter, provided the basis for discussion and material realization of a journal concerned with the critical analysis of visual culture, from a materialist position. Our historical precedents came, initially, from the tradition of marxist art history running from Frederick Antal,[4] Arnold Hauser, Max Raphael and Meyer Shapiro, through to the publications in the mid-1970s of T.J.Clark and Nicos Hadjinicolaou. In addition we wished to be actively involved in the rapidly developing specialism of design history by specifically resisting tendencies to reproduce the descriptive and historiographical categories of bourgeois art history.[5] In both of these respects we were acknowledging the hegemonic role played by the dominant forms of art history in the culture as a whole.

In his seminal essay 'Components of the National Culture', Perry Anderson outlined the significant aspects of English cultural traditionalism, particularly in their philosophical (Wittgenstein) and literary (Leavis) forms.[6] Anderson excluded discourses of art from his thesis on the grounds that their disproportionate emphasis upon subjectivity produced too complexly mediated relations to the social structure to clearly determine their effectivity. However, it has become clear since then that cultural analysis of social practices reveals the work they do, subjectively. Within the discursive

formation of hegemonic practices, which constitutes the totality of dominant and subordinate social and cultural relations, discourses of art in their traditional aesthetic, historical and evaluative modes have played, and continue to play, an important role in articulating individual and social identities. One particular example would be the cultural legitimacy provided by art history, for the construction of a 'national heritage' as an ideological site for renewing a selectively conservative vision of the past within the confines of an authoritarian, and ritualized, present. The resilience that art history has shown in the face of critiques levelled against it, is some indication of the flexibility of its defining principles, and the bob and weave techniques of its practitioners. Against these tendencies, *Block* represented an attempt to introduce a degree of theoretical rigour, historically specific analysis, and political critique into a discipline which overwhelmingly favoured a liberal-humanist account of visual culture.[7]

In an article published in the TLS in 1974, T.J. Clark called for

> a work of theory and practice. We need facts – about patronage, about art dealing, about the status of the artist, the structure of artistic production – but we need to know what questions to ask about the material. We need to import a new set of concepts, and keep them in being – build them into the method of work.

Clark's 'solution' was a restructured social history of art heavily dependent upon recent work within marxist theory, particularly post-Althusserian critiques of subjectivity, meaning as production and process as defined within semiotics, and a close attention to the material and ideological determinants upon artistic production and reception.

However valuable and influential Clark's approach has been, two elements missing or excluded from his work have been central to the direction that *Block* has taken over the last two years. The first concerns the objects of study. Whatever displacements the social history of art has effected upon traditional art-historical discourse, for the most part the body of

works loosely representing the 'canon' has remained in situ. Although critical study and ideological analysis have contributed to the deconstruction of the paradigms of the discipline – the assumed autonomy and apolitical nature of cultural practice, the prioritizing of the artist, style as a category of individual genius, etc. – the body of works thus disturbed have not been decentred: they still determine the majority of interpretations across the art-historical and critical fields. *Block* has published a number of articles that go 'against the grain' in this respect, including work by Barry Curtis and myself on representations of the Great War, Nicos Hadjinicolaou, Michel Thevoz and Adrian Rifkin on the conditions of the production, circulation and reception of French nineteenth century paintings and prints, Dick Hebdige on Pop art and the construction of taste, aspects of design history and, crucially, the work of feminist art historians and critics, particularly Lisa Tickner and Griselda Pollock.

The other element missing from Clark's (earlier) work has been some reflection upon the complex interrelations between power and knowledge operating independently of the individual subject.[8] To some extent, this relates to a general reconceptualizing of Marx's historical subject defined by the labour theory of value, to an analysis of the technologies of power found in the work of Michel Foucault, Jean-François Lyotard and Jean Baudrillard. Consequently, it has never been our intention on *Block* simply to redefine the theoretical status of the artwork and artistic subject, but rather both to critique existing epistemological frameworks of art-historical discourse, and to challenge its institutional status and authority. Put more directly, not only to question what sort of knowledge is on offer, but to see the production of knowledge, (or what passes for knowledge), as a site within a network of practices – social, cultural, academic, political – where there are always hegemonic relations of dominance and subordination at stake.[9] The major influence upon these developments has come from that body of feminist writing and theory whose primary objective has been to show how gender relations of dominance and subordination are legitimized and repro-

duced across the whole range of social and cultural practices. In the area of the visual arts, feminist historians and critics have examined the role that imagery performs both currently and historically in this process, and the political ramifications attendant upon understanding the operations of power in the formation of systems of visual representation. Again the work of Griselda Pollock and Lisa Tickner has been central here, along with analyses of advertising and design by Kathy Myers and Phil Goodall, Claire Pajaczkowska on structuralist theories of art, and the theories and practice of artists – Mary Kelly, Carol Conde and Karl Beveridge, Mitra Tabrizian and Martha Rosler.

It is important to recognize, in this context, that theory can either be employed to polish up the tarnished institutions of art, or be directed towards an attempt to transform those institutions through attending to new cultural forms and practices which do not merely extend the list of creditable objects for study, but fundamentally rearrange the categories. Thus the patriarchal and Euro-centric nature of high culture in the West, and its legitimizing role within broader socio-economic and geo-political hierarchies, is as much a site for the struggle and determination of meanings, as the modes of address and forms of evaluation themselves.

The analysis of visual culture, particularly as this has been reproduced through articles in *Block*, has tended to follow two related, but not necessarily interdependent, developments. One has stressed art as a social and material practice, resulting in specific cultural forms, and prioritizing production as the major determinant upon cultural commodification. Although this has provided a necessary input of empirical research into discourses on art, particularly around questions of patronage and reception, there has been a tendency to reproduce a realist ontology; that is, to read off the characteristics of a cultural product and its attendant use-value from the conditions of its production.[10] Such analysis, when applied to the modern period, has to be clearly situated within a framework of the stages of the uneven development of capital, from market economy, through monopoly capitalism, to the totally pene-

trated spaces of multinational capitalism today. And it should also, of course, take account of the arguments for a postmodern 'epistemic break', where the referent of social structures is no longer industrial production, but the post-industrial technologies of computerization and the storage and retrieval possibilities of the databank. With each of these stages, the work of culture cannot be seen as a mere reflection of a specific economic mode. Thus the history of high modernism has been documented as determined by a triangulation of three distinct elements: the hegemony of the Academy in the late nineteenth century leading to the production of resistant cultural forms, the rapidly developing technologies of mass communications and social mobilities and thirdly, the proximity of social revolution legitimizing the utopian visions of cultural radicalism.[11]

The second major theoretical input into art-historical discourse has come from a combination of work around representation as a structure and process of ideology producing subject positions, and the social disciplining of technologies and regimes of power which have material effects upon our lives and experiences. This emphasis has tended to take analysis away from the realist paradigm towards questioning the epistemological strategies and values of representation itself. In relation to specific cultural forms, this approach stresses their intertextuality; that is, the traditional appeals to artistic intentionality, the determinants of style, or the psychologizing of the artistic subject, are displaced by an emphasis upon the essentially plural and diffuse play of meanings across the boundaries of individual works and specific biographies. Here the major theoretical influences have come from film studies and cultural analysis, particularly the application of psychoanalytic concepts in the discussion of visual pleasure and the interplay of meaning and desire in the work of the text upon the reader. A number of artists whose work addresses these and related issues have featured in *Block*, including Victor Burgin, Marie Yates, Susan Hiller and Barbara Kruger, besides articles by Terry Smith on Frida Kahlo, Frank Mort and Nick Green on 'Visual Representation and Cultural Politics',

and Olivier Richon on visual representations of Orientalism.

In response to these developments, *Block* has increasingly attended to a wider range of cultural phenomena and critical theory drawn from mass media studies, subcultural analysis, ideology critique and critiques of the discourses of imperialism, besides political theory and Left cultural practices across a variety of media. This is not simply a matter of extending the range of reference to include the negativizing impulse of popular and mass cultural forms and practices, but to recognise that the struggles for cultural legitimacy take place across a discursive field composed of a variety of practices and subject positions, all of them exposed to the processes of commodification and spectacularization. If one effect of the 'postmodern condition' is a suspicion of the claims of all emancipatory discourses, then political authenticity and intellectual responsibility are constantly being redefined in relation to the codes of opposition and marginality. I think that we had something like this in mind when we suggested in the editorial for *Block* 10 that we now see our project as being to 'respond to, and map, the dynamic of current and historical forces as they interconnect and redefine the varieties of social experience, with particular reference to visual culture'. And we concluded that we wished to do so 'in ways in which the construction of cultural categories, and an effective cultural politics, can be an illuminating and participatory process for all, rather than a purely hermetic circle of intellectual and academic interest.'

Notes

1 Pierre Bourdieu, *Outline of a Theory of Practice*, trans. Richard Nice, Cambridge 1977, p.1-2.
2 It should be noted that although Block has always been a collective endeavour, this account is my own interpretation of its development and range of reference. In this I naturally hope that I am not misrepresenting the signi-

ficant aspects of a joint project. Besides myself, the edito-
rial group has comprised Barry Curtis, Michael Evans,
Fran Hannah, Claire Pajaczkowska, Tim Putnam, Lisa
Tickner and John A. Walker.

3 To the best of my knowledge, this phrase was first descrip-
tively employed as a title for a one-day conference I orga-
nized at Middlesex Polytechnic in 1982. On that occasion,
however, a question mark was appended.

4 Antal, in common with other commentators upon
bourgeois art history, recognised the fulcrum, and stick-
ing point, of the discipline: 'the most deep-rooted
nineteenth century belief, inherited from Romanticism,
of the incalculable nature of genius in art'. F. Antal, *Essays
in Classicism and Romanticism*, London 1966.

5 In line with Raymond Williams's definition, I would here
take 'bourgeois art history' to signify the historical de-
velopment of a discipline of connoisseurship which in its
distinctive forms valorizes the individual (male) artist, the
masterpiece, and the idealized Nation-State, as the domi-
nant and appropriate objects of study. As such, art history
reproduces the category of the subject as possessor and
producer of him/herself, and the democratic ideal of the
free individual and the consensus society. Fundamental to
this process is that most crucial hegemonic apparatus for
the experience of citizenship – the museum.

6 Perry Anderson, 'Components of the National Culture', in
A. Cockburn and R. Blackburn, eds., *Student Power*, Lon-
don 1969.

7 An influential text emphasizing the liberal-humanist con-
text for art-historical discourse was Panofsky's *The History
of Art as a Humanistic Discipline* (1940). In this, he defined
humanism as: 'not so much a movement as an attitude
which can be defined as the conviction of the dignity
of man, based on both the insistence of human values
(rationality, freedom) and the acceptance of human limi-
tations (fallibility, frailty); from this two possibilities
result – responsibility and tolerance...' If the historical
antecedents to this formulation lie in Hobbes's and Locke's

individual subject within bourgeois society, then a recent cultural manifestation is to be found in Kenneth Clark's *Civilisation*.

8 T.J. Clark's most recent book *The Painting of Modern Life* (London 1985), takes much greater account of this area of theory, and is indebted to the writings of the International Situationists, particularly Guy Debord's *Society of the Spectacle*.

9 An aspect of this is the rejection of any notion of knowledge production in general, for a relational model of discourses of knowledge answerable to specific requirements of adequacy. Specifically this relates to both Foucault's and Althusser's formulation of a 'problematic' as any discourse which 'can only pose problems on the terrain and within the horizon of a definite theoretical structure, its problematic which constitutes its absolute and definite condition of possibility, and hence the absolute determination of the forms in which all problems must be posed, at any given moment.' Louis Althusser and Etienne Balibar, *Reading Capital*, trans. Ben Brewster, London 1972.

10 For example see the responses by Peter Wollen and Art & Language to T.J. Clark's *Olympia* article: T.J. Clark, 'Preliminaries to a Possible Treatment of Olympia in 1865', *Screen*, Spring 1980; Peter Wollen, 'Manet, Modernism and the Avant-Garde', *Screen* vol.21 no.2, 1980; Charles Harrison, Michael Baldwin and Mel Ramsden, 'Manet's *Olympia* and Contradiction', *Block* 5, 1981.

11 For a full discussion of these points see Perry Anderson, 'Modernity and Revolution', NLR 144, 1984 and Frederic Jameson, 'The Cultural Logic of Capital', NLR 146, 1984.

Block is available from Art History Dept, Middlesex Polytechnic, Cat Hill, East Barnet, Herts.

'Something About Photography Theory'

Victor Burgin

Introduction

I sent the following transcript of a talk on photography theory to the editors of this volume in response to their request for an essay on the theme, 'consequences of the new art history for the study of photography'. I had to explain then, as I must now, that in replying in this way I was opting for the tangential in preference to the taciturn, for the 'new art history' has had no consequences for the study of photography.

As generally understood, the 'new art history' is in opposition to the widespread tendency of art historians, and art critics, to isolate works of art from the broader social circumstances of their production and reception; the tendency to construct, as I expressed it elsewhere, 'a sort of tunnel driven through history... along which wander the spirits of "Great Artists", shackled like the ghost of Marley to their "Great Works" '.[1] The 'new' art history differs from the 'old' precisely in that it seeks to restore to art history the missing dimension of lived social relations; the expression 'new art history' therefore is another way of saying 'social history of art'. The social history of art is of course not new; what is new (or more correctly *was* new, ten or fifteen years ago) is the promise, or threat, that the 'social history' approach might become the

dominant one in university art departments.

As defined above, the new art history has an obvious claim to be an improvement on the old; however, it is an improvement to an existing structure, and the foundations have remained untouched. For example, 'history' is still conceived as at once 'over' (completed) and 'over there' (distanced); art historical research is still seen as working on the past in much the same way as certain chemicals work on a latent photographic image, an image which simply needs to be adequately developed in order to emerge in all its immutable detail. Or again, the unexamined notion of the 'art object', a legacy of art history's origins in antiquarianism and connoisseurship, still remains of founding centrality; indeed, even the established canon of taste remains largely intact – the new art history being content simply to fill in the previously empty social space around the inherited 'masterpiece' with a glut of detail purporting to establish its 'determinations' in the (mainly economic) class relations of which art in general is seen as the more or less 'mediated' expression. In short, the unswerving positivism of the new art history renders it as incapable as was the idealism of the 'old' of examining the modes of constitution of its putative objects *within* its own discourses, and the positions (institutional, national, racial, sexual, etc.) from which these discourses are spoken.

Although the study of photography has had to cope with the ideological inheritance from art history, it has not (perhaps because it has evolved within the polytechnic rather than the university) had to struggle with its *institutional* inertia. In the following talk, originally addressed to a specific institutional conjuncture,[2] I do not refer to the 'new art history' as such; I do nevertheless characterize the transition from 'old' to 'new' attitudes here in terms of the individual human subject which each seems to presuppose: in the former, obeying the dogma of the 'purely visual', the subject is reduced to a disembodied eye; in the latter the eye is restored to a body, but a body conceived solely as an agent in the economic relations of production. In a 'third phase' of theoretical attitudes to which I refer – a phase the new art history has not yet entered

– the labouring body is further attributed a sexuality and an unconscious, attributions inseparable from the recognition that this body is a *speaking* subject, but a subject which is as much *spoken* by, constructed within, the very systems of representation it purportedly commands. It is in this perspective – that of psychoanalysis and 'post-structuralist' theory – that I conclude that 'photography theory' is not an independent discipline but is rather 'an emphasis within a general history and theory of representations'. The same conclusion must be applied to 'art history'.

'New art history'/'the study of photography' – a familiar prejudice has infiltrated the very terms of my brief: the word 'photography' names a medium, whereas the word 'art' names a *value* which it implicitly confers on the mediums of painting and sculpture. It is in the name of this value that 'art history' in this country has defended its frontiers against post-structuralism's barbarian hordes. The threat of 'theory' is presently being controlled by a policy of assimilation by selective immigration. Amongst the more subversive considerations denied entry: discussion of such oppositions as 'art'/'photography' within a critique of the 'logic of the supplement'; interrogation of the 'object', the 'masterpiece', within a critique of 'phallogocentrism'; general interrogation, in short, of the *performative* aspects of the discursive formations of 'art history', attention which goes beyond what the old or new art history may have to *say*. As John Tagg has put it in a recent succinct critique of the new art history, 'The question to ask is not "What does it express?" but "What does it do?" '.[3]

'Something About Photography Theory'

I've been asked to 'say something about photography theory'. My remarks this evening are produced out of and into the context of photography education.

We're here to talk about theory. Many people are against it. Theory gets in the way of spontaneity. Theory is a realm of bloodless abstractions which have nothing to do with the cut-

and-thrust of practice. For us, however, there is no state of
Edenic innocence outside of theories. If we were ever in such a
state, we lost it long ago when we learned to speak. If you can
understand what I'm saying then your views of the world,
whatever they may be, rest on a foundation of mainly tacit,
unspoken, assumptions which make up the interlocking com-
plex of theories we know as 'common sense'. As for spontanei-
ty, Pascal asked the question: 'Who knows but that second
nature is not merely first habit?'.

All discourses rest on assumptions which imply theories
about the way things are. All discourses are 'theoretical', the
discourses we *call* theoretical are self-consciously so. Theory
sets out to question the underlying assumptions of common
sense in order to replace them, where necessary, with better-
founded,or more comprehensive, explanations. In this it dis-
tinguishes itself from criticism. Criticism, as most commonly
practised, is concerned not with explanations but with value-
judgements. To support his or her judgements the critic char-
acteristically advances arguments which when examined rare-
ly prove to be *arguments*, properly speaking, but rather *asser-
tions* of opinions paraded as if their authority was unquestion-
able. Critical discourse tends to be studded with such untheo-
rized items of common sense as 'greatness', 'originality', 'spir-
ituality', and so on, most of which can be traced to humanist
doctrines which emerged in the West in the transition from
Medieval to Renaissance world pictures; to the liberal indi-
vidualism which emerged in the seventeenth century, notably
in the writings of the British philosopher John Locke; to the
romanticism of the late eighteenth and early nineteenth cen-
turies; and so on. Upon a foundation of romantic liberal-
humanism there is most often then erected a formalist aesthe-
tics derived, generally via Greenberg, from the English
Bloomsbury Edwardians Clive Bell and Roger Fry; or the
derivation may be *fin-de-siècle* symbolism; or nineteenth-
century realism; or an amalgam of a number of these theories.
The implicit politics of such forms of criticism tend most often
to be derived from Matthew Arnold: with the decline of reli-
gion only art can provide the spiritual cement which will

keep the crumbling edifice of the *status quo* society from col-
lapsing. My point in making these generalizations is simply
this: the assumptions operative within criticism are theoretic-
al, and they have a history. Both of these facts are suppressed
within criticism, where the critic speaks as if the criteria being
applied were unquestionably self-evident, timeless laws of na-
ture.

A second discursive regime overlaps and interweaves with
criticism: this is 'history'. Whereas, in the school, the setting of
criticism tends to be the studio, the setting of history is the
lecture theatre. In fact, criticism and the history of photogra-
phy are in a symbiotic relationship – the one could not survive
without the other. The discourse of criticism throws up its
subjects and objects of value, 'great' photographers and
photographs, which it is then the business of history to
arrange into a meaningful narrative sequence. That this
narrative is overwhelmingly one of linear descent, of *patri-
mony*, should alert us to the fact that, psychologically, like all
good narratives, history is conceived in *Oedipal* terms. From a
sociological point of view,it is the function of 'history' to legiti-
mate careers and commodities – history-writing as underwrit-
ing. In the history of photography we find the unargued
assumptions of criticism projected into the past in order that
they might return miraculously transmogrified into the indis-
putable 'facts' of history. There are, of course, exceptions –
I'm talking about what is *normal*.

A third discursive regime, in the art and photography edu-
cational institution, most often found playing gooseberry to
the love-affair between criticism and history, is what has alter-
natively been called 'liberal' or 'complementary' studies.
Liberal studies means just that – you study to be a liberal.
Casting my mind back to my art-school days: this week a bio-
chemist shows slides of crystalline structures which may excite
the painters and fabric-designers to a fever of creativity; next
week an evangelical existentialist will convince us of our inhe-
rent capacity to forge the world according to our own life-
project, all 50 of us. 'Complementary studies', when I was at
art school, was liberal studies with a pedagogic conscience – an

attempt to offer courses which were truly complementary to the field of study in question. It is here that there occurred the first stirrings of theory in the art and photography education syllabus, and it is here that the question arises, 'What theory is complementary to photography?'.

Basically, theories may be distinguished one from another according to either their method or their object. I'll leave the question of method on one side for the moment; I'll come to it later. Most immediately, I think we would all be inclined to say, photography theory has its own specific *object*. But there is a complication, theories don't simply *find* their object, sitting waiting for them in the world, theories also *constitute* that object. It seems reasonable to assume that the object of photography theory is, at base, the photograph. But what *is* a photograph? When photography first emerged into the context of nineteenth-century aesthetics, it was initially taken to be an automatic record of a reality, then it was quickly contested that it was the expression of an individual, and then a consensus was arrived at which perhaps has the strongest support today: a photograph is a record of a reality refracted through a sensibility. Put another way: what I see is something seen the way someone else saw it. I put it this way to bring out the emphasis on *seeing*: 'photography is a visual medium'. This is certainly where complementary studies overwhelmingly located theory – in theories of *vision*: the philosophy, psychology, and physiology of perception. We learned from these theories that a photograph does not replicate our act of perception, nor does our act of perception replicate the world 'as it is' (although what was meant *here* was never quite clear; I'll come back to this).

There are two main objections to conceiving of the theory of photography as a branch of cognitive psychology, either in this brute sense or in a more mediated sense – for example, by analogy with the psychologically informed theory of art put forward by Ernst Gombrich in *Art and Illusion*. In the first place, such theories of perception have nothing to say about the social world from which and into which photographs are produced. Secondly, the spectator – photographer, or mem-

ber of the audience for photographs – the spectator assumed by such theories is itself an entity outside of society and history. Essentially, the spectating subject of such theories is a disembodied *eye*, albeit an eye connected to complex neurological/psychological circuits. The subject of such theories is without gender, race, class, age, or affectional preferences. Not to be able to talk about such things within the theory of photography would be a disadvantage. Clearly, we should not criticize a theory for failing to do what it never set out to do in the first place; equally clearly, theories of perception do not get us very far in our understanding of photography in its various uses. I suspect it is this very limitation of theories of perception which allowed them a virtual hegemony within complementary studies in art and photography education – the fact that there is nothing in the theory which actually *contradicts* the tenets of dominant history and criticism.

One response to the ubiquitous tendency within the 'fine art' tradition to bracket out considerations of history and ideology in order to create a pure category, 'art', which somehow gives birth to itself 'apart from', 'in spite of', 'above' lived social relations, has been to turn to sociological theories, particularly those based in the marxist tradition. Marxist history and sociology seeks to restore the missing accounts of such things as the social and historical context of the images in question; the conditions of work, economic dependencies, and ideological affiliations of those who produce and consume such images. The spectating subject is now no longer simply an eye, the eye now belongs to a labouring body. This has been, and will continue to be, *necessary* work; however, when it claims to be both necessary and *sufficient* it is seriously disadvantaged by the legacy of an inadequate theory of ideology. Perception theories posit a simply given entity, the world of appearances, the realm of 'the visual', which is then inflected and nuanced in its passage through the image. A certain predominant form of marxist analysis posits a simply given entity, the world of economic productive relations, the realm of 'the social', which is then inflected and nuanced – in a

famous formulation, 'inverted' – in its passage through ideology. The abstract model in the otherwise incompatible approaches is the same: there is something concrete 'out there' which precedes representations, and against which the representations may be tested for their degree of correspondence to, or deviation from, the real. At its most reductive, this has allowed a certain type of marxist sociologism to assign images to a bipartisan form of classification in terms of their affiliation either to capital or labour, fostering that illusion of 'left' photographers that there is such a thing as a 'political' photograph – 'socialism in one image'. In rejecting, here, a certain simplistic form of marxist theory I do no more than repeat arguments which have emerged over recent years from *within* marxist cultural studies: the only world we can know is a world which is always already *represented*. Let me give a concrete example of the sort of shift in critical perspective entailed by a rejection of the subject/object epistemology, particularly, the abstract model in which the perceiving subject compares a reality with its representation.

One of the most influential achievements of the women's movement, in the field of cultural theory, has been its insistence on the extent to which the collusion of women in their own oppression has been exacted *through* representations. Feminist theorists argued that the predominant visual and verbal representations of women in circulation in our male-dominated society do not reflect, re-present, a biologically given 'feminine nature', natural and therefore unchangeable. They argued that what women have to adapt to as their femininity, particularly in the process of growing up, is itself a *product* of representations. The question to be asked, therefore, in looking at, say, an advertising image of a woman – or, of course, a man – the question should not be, 'Is this a *true* representation of a woman, or of a man?', but rather, 'What are the *effects* of this image likely to be?'. I'm reminded of Godard's remark: '*Ce n'est pas une image juste, c'est juste une image*' – but of course it's never 'just an image', the image always *means* something, and it's in accordance with such meanings that people live and act.

This observation brings me to what I believe is the most important feature of the phenomenon of the photograph in society: photographs *mean*. The various forms of photographic practice contribute to the production, reproduction, dissemination, of the everyday meanings within the framework of which we act. I believe this fact is fundamental; we should not lose sight of it when we attend to other aspects of photography – the photograph as a picture, or as a token in a system of economic exchange, or whatever. The idea of photography as something used to engender meanings has of course been with us as long as the notion, particularly prevalent during the heyday of the picture-magazine, that photography is a *language*. However, although it had long been common for people to refer to 'the language of photography', it was not until the late 1950s to mid-60s that there was any real interrogation of the supposed analogy between 'natural language' – speech and writing – and signifying systems other than language, systems like photography. These early investigations, conducted using the tools of linguistic analysis, demonstrated that there is in fact no 'language of photography' as such, no singular, unique, system of signification upon which all photographs depend, in the sense in which all sentences in English depend on the English language. It was argued that there is rather a heterogeneous collection of codes upon which photography may draw, but very few of which can be said to be unique to photography. For example, all photographers know that the way they light a face for portraiture can 'say' something – ruggedness, spirituality, weirdness, or whatever – but such lighting codes can be seen at work in painting, or in the theatre, long before they are used in photography. The type of analysis I'm talking about, conducted from the standpoint of linguistics, is of course the type we know as *semiology*. The main gain of semiological analysis was in its deconstruction of the apparent 'naturalness' of the meanings produced when we look at photographs. We might remember that much of this work, in its earlier phases – I'm thinking particularly of the early Barthes, of *Mythologies* – much of this work was conceived of as a work of 'demystifica-

tion' – ironic, considering how mystified most people are
when they first encounter the semiological texts.

Semiology came under *theoretical* attack, however, on this
issue of the spectating *subject* implied by the theory. In semiol-
ogy the subject is little other than an encoding/decoding
machine: we still have a problem using the theory to connect
the photograph to those factors like class, race, age, sex, which
are so important to us all. Another, allied, problem stemmed
from the sort of linguistics being used – all the encoding/
decoding machines work the same way and understand the
messages in the same way. If I send you a lump of cheese in a
wrapper, it remains just that when you receive it; but if I send
you a meaning in a photograph...? Actually, I've just been
reminded of Mao's remark about the pear: to know the taste
of the pear you have to *change* the pear by eating it. OK, forget
the analogies, the point is that we can't leave our sex, age, class,
etc., out of consideration in trying to understand the way
meanings are produced. The question then became, '*how* is
our subjectivity *involved* in producing meaning when we're
confronted with a text?'.

By the early 1970s semiology had undergone a radical
transformation from within, in the course of which the ling-
uistic model became displaced within a broader complex of
methodologies – most notably those of Freudian and Laca-
nian psychoanalysis. In this second revolution in theory,
emphasis was shifted, as the title of one of Barthes' essays from
this period puts it, 'From Work to Text'. In structuralist semi-
ology the particular object of analysis (novel, photograph, or
whatever) was conceived of as a self-contained entity, a 'work',
whose capacity to *mean* was nevertheless dependent upon
underlying formal 'structures' common to all such works – the
task of theory was to uncover and describe these structures.
This approach provided what we might call an 'anatomy' of
meaning production; however, as an 'anatomical' science, it
was unable to say anything about the constantly changing
'flesh' of meaning. *Text*, as conceived of by Barthes (with the
prompting of, most notably, Jacques Derrida and Julia Kriste-
va), is seen not as an 'object' but rather as a 'space' between the

object and the reader/viewer – a space made up of endlessly proliferating meanings which have no stable point of origin, nor of closure. In the concept of 'text' the boundaries which enclosed the 'work' are dissolved; the text opens continually into other texts, the space of *intertextuality.*

For example, there's recently been in circulation, in England, an advertisement which shows a bottle of Vermouth and, standing in front of it, a glass slipper containing some ice-cubes and a measure of the drink. Well, instantly, when I look at this image, I'm referred to the story of Cinderella and its themes of rags-to-riches and romantic love, which in their turn can potentially hook into specific contents in my own personal history. I'm also referred to the idea of 'drinking from a slipper', the image of *fin-de-siècle* playboys and chorus-girls, and all this image may evoke in terms of physical sexuality. As a European of a certain age I'm reminded of the expression, 'on the rocks', which evokes *film noir* detectives in belted trench-coats sipping bourbon in piano-bars; and so it goes on. All of these associations, and more, belong to the fields of what Barthes calls the *'déjà-lu'*: everything we already know and which the image may therefore evoke, whether by intention or not. These intertextual fields are themselves, of course, in constant process of change, they are historically specific.

The psychic processes by which any single image can spark an explosion of associations – visual and verbal images – are those of the *unconscious*, what Freud called the 'primary processes'. The particular trajectories launched through the ever-shifting intertextual fields skip, stepping-stone fashion, and 'dissolve', along the traces of the spectator's phantasies/ histories. A consequence of this theory, informed by psychoanalysis, has been to further add to the theoretical model of the spectator: the body not only labours, it also *desires*. Clearly, then, there can never be any final closure of the meanings of an image; there can never be any question of arriving at the sum of signification, the parts will never add up to a non-contradictory whole. One result of 'post-structuralist' theory therefore has been to demonstrate the futility of any

theology of *origins* of meanings such as is present in the subject/object epistemology, the base/superstructure metaphor, and to which structuralism tended to revert in the idea of *structure* itself. Furthermore, and this has important consequences for photography theory, the concept of the intertextual generation of all meaning entails that we cannot theorize the production of meaning in photography without taking into account all other sites of meaning production within a given culture at a given moment in history.

In talking about theoretical approaches to photography I've so far mentioned cognitive psychology, sociology, semiology, and psychoanalysis. Clearly, photography theory has no methodology peculiarly its own. Equally clearly, the wide range of types of photographic practices across a variety of disparate institutions – advertising, amateur, art, journalism, etc. – means that photography theory has an *object* of its own only in the very minimal sense that it is concerned with signifying practices in which still images are produced by an instrumentality more automatic than had been previous ways of producing images. This instrumentality, the camera and film, is itself in the process of changing, a change accelerating rapidly with the advent of the microchip. Photography theory therefore is not, nor is it ever destined to be, an autonomous discipline. It is rather an *emphasis* within a general history and theory of representations. And I should say, even though I only have time to say it in passing, that there is absolutely no reason for us to go on talking as if this history and theory began in the nineteenth century. There is, for example, a wealth of pertinent history and theory – I'm speaking now from the point of view of semiotics – in the period from, roughly, the sixteenth to the eighteenth centuries. I'm thinking of the debates around the doctrine of *ut pictura poesis* which bound all picture-making in the Renaissance to considerations of discourse; I'm thinking of the tradition of the Emblem and the Impresa, where we can find so much of interest to more recent, psychoanalytically inspired, theories of representation.

In this almost infinitely extensive field of possible theoretic-

al approaches there is no direction of work, in the name of photography theory, which is simply given to us in advance. The method(s) we select will depend on our goals – what do we want to *do* with this theory? For my own part, I can see no point in doing the work unless I can believe that it *matters* in some more than merely academic sense. I've said I believe that the most salient characteristic of photography, seen in the context of history and society, is the contribution it makes to the (re)-production and dissemination of meaning. Since Foucault we can be in no doubt that the production of meaning is insepar-able from the production of power. Photography inserts itself into the networks of what Foucault calls the 'capillary action' of power through its contribution to the nexus of desire and representation, which includes, for example, the question of who and/or what is represented and *how*. Photography theory can seek to reveal and account for the processes by which this contribution is made. Photography theory is itself engaged in this process through being now caught up in the apparatus of the educational institution. Caught up internally, where it is a matter of such things as competing discourses within the academic institutions, and the accreditation of future 'ex-perts'. And caught up externally, where it is a matter of the relation of the educational institution to the State and other ruling interests.

Here, we might remember the observation of that occasion-al, but influential, writer on photography, Walter Benjamin: even work with a radical content may nevertheless serve an apparatus which can do no other than perpetuate the *status quo*. We should be wary of the capacity of theory within the educational institution to reproduce the authority structures of patriarchy in general. In my own teaching I must struggle – especially now, in the context of educational 'cutbacks' – with the medieval legacy of the lecture theatre, and with the ne-cessity of imposing a syllabus which must be enforced through an oppressive apparatus of examination and accreditation. I do not believe that the alternative to this alienating system is the sort of *laissez-faire* anarchy I encountered in my days in art schools. I remember a remark made by the Russian Formalist

critic Viktor Shklovsky; speaking of a friend he said: 'He was educated as an artist, which is to say he wasn't really *educated* at all.' I'm thinking of that prevailing anti-intellectualism which presents itself as liberalism but which in fact is the masquerade of a petrified conservatism. I do not know, under the present circumstances, what the alternatives can be. I am sure however that, as a teacher, I must be judged for my progress on this front, as well as for the elegance of my presentations and the comprehensiveness of my bibliographies.

Notes

1 'The Absence of Presence: Conceptualism and Post-Modernisms', in Victor Burgin, *The End of Art Theory*, London 1986.
2 The School of Communication of Ryerson Polytechnical Institute, Toronto, was in the process of introducing courses in the theory of photography into its syllabus when they invited four speakers – Victor Burgin, Hollis Frampton, Allan Sekula and Joel Snyder – to give public talks on the topic, 'Theory of Photography'. The talks were given on 30 September, 1983. Victor Burgin's contribution, reprinted below, was first published in *Screen*, vol.25, no.1, Jan./Feb. 1984.
3 John Tagg, 'Art History and Difference' in *Block* 10, and reprinted in this collection. The context of the sentence I quote is a discussion of the new art history's relation to its objects, but it is not inconsistent with Tagg's argument to apply the line to the discourse as a whole.

Teaching and Learning

Mary F. Gormally and Pamela Gerrish Nunn

The new art historian is not necessarily an inhabitant of the university seminar room. In our experience, the new art historian is often unemployed,or an unwelcome part-timer in an arid and blinkered institution, or an occasional voice in a parochial wilderness. In the prevailing climate – of old school tie, academicism and connoisseurship in the history of art, and of unemployment, cuts and productivity-mindedness in education – the new art historian's principal problem is to find a living. It is difficult to feel either effective or satisfied as a new art historian sitting amongst your books in your own room, changing nappies between chapters, or queueing at the DHSS. In this setting, the adjective 'new' in one's title comes chiefly to mean that one is less likely to find paid work and more likely to feel isolated and unfulfilled than a plain art historian. The 'newness' becomes the albatross around one's neck, albeit also the cross one has chosen to bear and the light by which one travels.

The occupation that an art historian of any school can most obviously take up is teaching. Writing is hedged around with fundamental practical questions such as how one makes a living and how one finds a readership, while museum and

gallery work involves a very particular channelling of art-historical expertise into a field which is considerably smaller than that of education. We believe that teaching and learning art history should be challenging to the society, valuable to the student, and enjoyable to the art historian – but we live in a very imperfect world.

Though there seems to be something approaching 'the new school tie' for men engaged in re-describing the history of art, for female new art historians opportunities can be few and far between and if they arise, beset by many practical problems. A new art historian who is female will be a feminist, and this will bring her trying times in the workplace. She will probably be an occasional, part-time, or at best junior member of the department which has favoured her with employment, and this low status, combined with her radical approach to her subject, will render her unwelcome, peculiar, or ripe for mockery in many colleagues' eyes.

In further and higher education at the moment a certain amount of lip service is paid to new approaches in art history, feminism being the most topical and the most urgent in many institutions because of the embarrassing fact that while a probable majority of the students is female, the entire body of teaching staff may well be male. (Those whose experience of tertiary education is based on the university model, often fail to realize the extent of the scarcity of female staff in faculties of art and design.) This can mean that the new art historian has been brought in because she is radical, but not because she is genuinely wanted in the department by her colleagues. That this is so she will gather from various factors: the presence in the department – sometimes in the rooms she must work in – of sexist, or even pornographic, posters and notices; the absence from the slide collection and library of any work by or on women artists; the condescension or dismissal which greets her lecture titles or her reports of good seminars; the facetious interrogation about her private life and opinions which she is expected cheerfully to undergo; and the catalogue of offence, frustration and manipulation with which the female students will regale her when they get her on their own. The new art

historian of whom we speak may well also be a mother, and another signal of the nuisance she represents will be the scarcely-veiled impatience with which the resultant complexities of her routine and constraints on her timetable will be tolerated by colleagues, some of whom will imply that she is a lesser art historian because she has more difficulty in meeting logistic demands.

Her ability to be a good art historian – or, rather, to show herself to be – will depend considerably on how well she is able to resist the constant calling into account, both by students and colleagues, of herself, her beliefs and her expertise. If she has no sympathetic colleagues, the sense that she is 'guilty until proved innocent' will hang in the air of the staff-room, lecture-hall and seminar room; and of course she doesn't possess the passport to 'innocence' – being one of the boys. The patent fact that she doesn't wish to be one of the boys exacerbates the tensions of the situation – hell hath no fury like patriarchy scorn'd. Additionally her credibility with staff and students alike can depend upon the amount of free (i.e. unpaid) time she will spend searching out the materials she needs in order to do what she has been employed to do, and the money (her own) which she is prepared to spend on getting slides made, providing written materials for back-up (and justification, in the eyes of some), and travelling to far-flung places which others can afford to shun. Before you can realistically canvas for lecturing work, you must have accumulated a reasonable amount of teaching material; the new art historian, by definition, will tend not to find this easily (or therefore, cheaply), for even though she may choose to teach about traditional figures, she will want to focus on their less familiar aspects. If she does not live in London, nor even in a city, she will have great difficulty in these respects. If she doesn't drive, or have access to a car, her prospects are even dimmer – in fact, in that case, she is probably already on her way to the local job centre to ask about retraining.

The new art historian may be prepared to feel like an outsider, but the degree of not belonging which some of us experience has nothing heroic about it at all, nothing perversely

glorious, noble, or lone-ranger-like – it is simply miserable and unproductive, and not at all new. These practical matters we have discussed have a bearing on who can become, in any meaningful sense, the new art historians. There is little new about an art history which issues only from the mouths and minds of men, of a certain colour and a certain class.

The new art history calls not only for new exponents but also for new contexts and new backdrops, and it must be prepared to go under certain guises which have heretofore been disdained, not to say reviled, by art historians, for example, art appreciation. In these new teaching situations, as on many traditional sites of learning, a woman may be an unfamiliar and unconvincing authority figure, and it will be a figure of authority – the teacher as expert – which the students require. Her dilemma is thus complex: as a new art historian (at least, as we as feminists understand the new art history), she has no wish to appear the fount of all true knowledge, delivering the tablets from the mountain, and as if she herself wrote them. Yet she has to establish the fact that a woman deserves the confidence of students and has a right to be in the teaching role. She must do this simply to ensure her classes continue to run, never mind because she feels a responsibility to promote the credibility of women teachers as such. 'Old' art history is not just the baggage of old art historians but of many students too. The crucial signs for them may well be things which seem peripheral to one's academic performance: punctuality, the quality of the slides, the class character of one's speech, ability to rattle off titles, sizes and dates with enthusiasm, and convincing presentation of valuable knowledge or insights as natural possessions. (They are, of course, the fruits of privilege.)

Our new art historian may be obliged to act 'old' in order to secure a job, and then hope to proceed to become a quite different sort of creature, as the butterfly emerges from the chrysalis. Her students will measure her against art historians with whom they are familiar – probably not 'new' – and, if the course is not to fold after the first class, she will need to meet their traditional standards if she is going to have the chance of

presenting them with new ones later on. To the traditionally-minded student, the woman at the front of the class talking of subjects that don't matter (women artists), in terms that are irrelevant to the study of art (class, race, gender), must at the very least assert her opinion as solid fact and smile graciously when she is patronized by the idiot male in the front row. If she does not she loses such students and almost certainly therefore her class.

With opportunities in the arts on the decrease, and innovation seen as an expensive luxury, the new art historian comes at a perverse time in the history of her subject's existence as an educational discipline in the western world. She comes also at a time when opportunities for women are correspondingly in decline, though women's energy and enterprise are running high. 'New' art history owes much of its existence, in fact, to women's work but, when it comes down to it, we as architects of the phenomenon are rarely free to claim our titles fully, fairly or confidently.

One educational area seen as appropriate for women to work is school. At the same time it is an area that is forgotten when art history is under discussion. New art historians are inclined to follow this path of prejudiced dismissal. Yet the problems confronted in teaching the new art history in secondary schools duplicate the struggles that are readily recognized in higher education.

At the time of writing, one of us worked in an independent girls' school in Bristol:

Last week my students took their history of art examination. My immediate glance at the paper was solely based on whether I had prepared them sufficiently to be able to answer many of the questions, and to pass the examination. That is one of my aims in teaching. It is not my only aim. It is the school's overriding aim.

Rarely does one find an art historian, of any political persuasion, employed in private or state schools solely to teach art history. Although, one's bank manager remains unconvinced about the seriousness of such a salary, it represents for those in authority an increasingly uneconomic use of human re-

sources; as education authorities indicate, all art teachers have done some history of art at some point in their training, so are therefore as well qualified to teach the subject as trained art historians.

As a trained and experienced teacher of art history I am employed to teach the history of European painting to two sixth-form groups. I teach each group for 80 minutes each week as part of the A-level art course. The school's attitude to art in the upper school sadly reflects the viewpoint of University Admission Boards that art is not a serious academic subject. Generally speaking, the students who choose the subject at A-level are academically 'weak' and more likely to combine the subject with needlework or home economics than with the literature or history which might reinforce the importance of a critical point of view. Some students find the weekly essay an arduous task, and occasionally class time is consumed in teaching basic skills.

The syllabus and examination paper remain undisturbed by the new art history. The syllabus is vast, from cave paintings to contemporary art; and the sheer size of such a syllabus, coupled with too little time and the felt imperative of obtaining successful examination results, is a powerful determining force in the way I teach the subject. The syllabus, the examination questions and the approach to marking them grandly assert that the 'old' art history is Art History. It is the history of European painting and sculpture, with the Italian Renaissance as the key to our understanding of all that went before and all that follows. For example, the 1984 history of art paper had four out of twelve questions specifically about Italian Renaissance painters and paintings. That focus was not unusual. Both the 1984 and 1985 papers opened with questions on Giotto. Therein lies a whole set of assumptions and values about art and artists, and a view of the world. These are reinforced by questions on schools of painting, styles of painting, and movements in painting, in which Neoclassicism, Romanticism, Impressionism and Expressionism have been hot favourites for the last ten years. There is no hint of the new art history here.

The staple text recommended by the Board and supplied by the school is Gombrich's *The Story of Art*, first published in 1950. Implied in that title is a certainty that the book contains the whole story of art. Clearly, as a feminist art historian teaching young women I have to point out that it is *one* story, and not an acceptable one to me. It is a text, like most art books in schools and public libraries, that emphasizes the artist (male) and concentrates exclusively on 'unbiased' appraisal of the art object.

As a teacher, one of my responsibilities is to challenge the notion of the history of art as a value-free discipline: however implicitly, paintings are about politics, religion, sex, money, social class, as well as aesthetics. That tendency in the old art history – from children's books to scholarly articles – to deflect, avoid and hide from key areas such as religion, sex, politics, and class should be challenged in teaching.

When I show the girls a slide of Titian's *Venus of Urbino*, I want to avoid the familiar and exclusive tendency of the old art history to dwell on compositional structure and Titian's brilliant use of light and colour in conveying the illusion of delicate and sensual flesh-tones. It is also a painting of a mortal and naked woman, elevated by title to the realms of mythology, occupying the foreground of the canvas and painted by a man described as a 'giant' of the Italian Renaissance. For me, as a feminist art historian with a group of young women students, something must be said about this. And it must be said in a way that does not undermine their confidence or alienate their interest and attention. Equally, I do not wish the students to see the entire area of sexual politics and the representation of women in art as something idiosyncratic to me. There is a recurrence of certain images of women in art and we need to question more than the quality of paintwork: what are these images of woman, painted by men and seen as Madonna, Eve, Venus or Happy Wife and Mother, helping to construct and support? Has this anything to do with our own lives, the way we experience ourselves, live out relationships, view our work or our children? Faced with a female nude, the girls state 'hasn't she got fat thighs'. I would be failing in my job if this did

not lead ultimately to a discussion of the power and influence of the fashion and slimming industries.

There is a total silence about women artists in the set text and the examination paper with which I cannot collude. Many of my students go on to art college, and they must be given some historical analysis of why women artists are excluded from the art history they encounter in their text, syllabus and examination. They must understand why in other texts they might encounter, women artists are trivialized, marginalized and dismissed as having small talent and no historical significance. I want them to understand why they will find plenty of women students at college but few women staff, and many of those part-timers. Try as I might, I cannot change the fact that some of my students seek jobs that the old art history and their socio-economic backgrounds readily prepare them for: connoisseurship. They seek positions in the privileged worlds of international art dealers and auction houses.

What can I hope to achieve, juggling the powerful demands of the old art history and my commitment to ways of teaching the subject excluded by these demands? I see my work as fostering ways of looking at pictures that open up levels of critical awareness, challenging students to think about the subject-matter in ways that not only furnish them with a language for pictorial analysis but also a language for dealing with ideas and meanings in pictures. I want to direct them towards a critical awareness of such issues as politics, sex, religion, race, money and class; and to understand the interests which great art and high scholarship serve. I believe this is the business of art history and of the teaching of art history – and in this I am at odds with the institution through which I function as an art historian.

* * *

We have shown how problematic the new art historian's existence is in reality, and we affirm our belief in the value and necessity of the new art history. But lip service is not enough: commitment and effort are essential. Much still has to change, both inside and outside the new art history, before it will achieve any significant and enduring shift of values.

New Lamps For Old

Tom Gretton

This essay does not offer a prescription for or an analysis of alternative art history. It is based rather on an understanding of the way current art history is structured.[1] Within history of art there are a variety of ideological and methodological tendencies, many of them in contradiction one with another. Nonetheless they share important positions, and tend to accept the same sorts of definitions of evidence and of significance.

History of art is a specialized discourse about certain classes of objects, including paintings, sculptures, prints, drawings, and certain aspects of buildings. Not only is it a specialized discourse, it has a special subject matter, which is not coextensive with all objects in these classes. Its subject matter is defined by reference to aesthetic criteria, and in particular to hierarchical judgements of worth. This process of judging, which is to a great extent taken for granted in the day-to-day work of art historians, functions in two ways. First it makes absolute distinctions between those images which are 'art' and those which are not, so that not all paintings, and very few printed images, for example, qualify. Secondly, within this arbitrarily defined group of objects the process of application of aesthetic criteria is constantly at work, as we re-evaluate the

place of Richard Wilson in British landscape art, re-examine Renoir's reputation or decide that a 'Duccio' is a 'follower of Duccio'. In as much as art historians take it for granted that the aesthetic criterion is one of their cardinal points of reference, their demonstrations that this painter was subservient to the class interests of his or her patrons, or that another painter is to be regarded as particularly interesting because of his or her subversive modifications to stylistic or generic conventions, can all be reduced to mere maintenance of the shrine of 'art' at which art historians collectively worship.

Not everyone who works in art history jobs in institutions of post-secondary education, not everyone writing books or making documentaries for Central Television about paintings, sculptures and similar objects does in fact operate with primary reference to 'art'. Histories of the institutions of painting, of the profession which we now call 'artist', as well as surveys of iconographical corpuses have been written, and are being written, in which the question 'is it art?' (on an affirmative answer to which history of art depends), can be circumvented, or even subverted. It is however worth noting that the relative autonomy which the more privileged art historians enjoy, and which permits them to issue paper challenges (like this one) to the boundaries and beliefs which structure their subject, are irrelevant to the way in which 'art' is produced and reproduced for wider audiences: more of this later.

Thus though there are a number of studies which deal with groups of 'visual objects' or of the historical institutions and other circumstances surrounding them, they do not represent the mainstream of the discipline. For most art historians 'art' does not designate a set of types of object – all paintings, sculptures, prints and so forth – but a subset arrived at by a more or less openly acknowledged selection on the basis of aesthetic criteria. But aesthetic criteria have no existence outside a specific historical situation; aesthetic values are falsely taken to be timeless. In the circumstances the category 'art' cannot be taken to have an absolute existence. Rather it is the name of a social relationship, in the first place between people and objects, but ultimately between people and people, a rela-

tionship which is disguised by its reification[2].

In claiming that 'art' is not an identifiable quality of objects but a socially constructed category through which we relate to, consume or otherwise appropriate objects, I am not claiming anything new. One can go on to show how the social construct 'art' is ideological, in the sense that it helps to maintain existing social relationships, and then to argue further that adjustments to art-historical discourse which accept that 'art' is the proper standpoint from which to write image histories are most unlikely, however earnestly they may try to subvert it, to do anything but reinforce the ideology of art, reinforce the hegemonic culture which 'art' helps to articulate.

Such a view minimizes the importance of the work which avant-garde painters and so forth are taken to do in disrupting the category 'art' within which they operate, and by doing so, forcing themselves, and their spectators, to rethink not only the category, but its relationship to wider social structures, and thus those wider structures themselves. Such an outcome is impossible for an orthodox base/superstructure marxist to envisage, since, for example, Courbet's ideas about monocular perspective must be seen within orthodox marxism as minute bubbles on the frothiest part of the waves thrown up by the profound convulsions of the nineteenth-century French socio-economy. Even a marxist who regards ideology as a material force, and thus works not with a one-way flow of determinations from the economic to the cultural level, but with a system in which economic, social and cultural phenomena are linked in mutually determining relationships, can scarcely avoid acknowledging that in such a system the forces of determination flow much more strongly in one way than they do in the other. This argument should not be taken to deny the possibility of contradictions within the sphere of ideology being resolved by an evolution in an aspect of the mode of production. Its thrust is to show that arguments within 'art', or about it, are most unlikely to contribute to any such changes, because of the particular way in which the category 'art' is produced and reproduced.

The fundamental way in which 'art' is an ideologically op-

erative category is that it both reinforces and disguises our sense of alienation, our sense that to be in charge of our own destinies is inappropriate. Art production is identified with self-determining production, and at the same time is marginalized, is defined as useless production, in contrast to the production of Mars Bars or washing machines, and even in contrast to the work that we call 'design' and 'craft'. 'Artists' are generally characterized as living marginally, both in terms of their economic conditions and in terms of their lifestyle. Over the last century and a half concepts such as that of Bohemia have been much more successful in constituting the public persona 'artist' than the earnest attempts of a large number of painters and so forth over the same period to live 'bourgeois' lives, and to convince the world of the respectability, of the ordinariness of the profession. Painters and so forth are stereotyped as special people, as 'artists'. For the rest of us, economic activity, and to a large extent self-defining social personality, which should, within the overarching ideology of bourgeois individualism, be the goal of everyone and an accepted norm of social and economic arrangements, is transformed by the place of 'art' in capitalism, and probably within industrialized commodity production as a whole, into a fetish. It becomes a limited and limiting, not a general, social option, a specifically useless, not a generally desirable mode of economic activity. What would be the effect on capitalism if we all decided that we wanted to define for ourselves how we worked, what we worked upon, how what we did was to be used and understood? One has only to ask the question to see the importance of producing an ideology which makes such ambitions inappropriate, somehow out of the question. Art does this job. The specialness of art today is the same as the specialness of artists. The bible of history of art, E.H. Gombrich's *The Story of Art*, begins its Introduction with words which say exactly this: 'There really is no such thing as Art. There are only artists.' The special status of art and of art production is a guarantee of the ordinariness, the naturalness of the social and economic relations of commodity and service production within capitalism – and within 'state capitalism' too.

Within this overall ideological function of the concept, functions which are more closely connected with the maintenance of the social hierarchy, rather than the division of labour as such, can be discerned. The material or symbolic appropriation of works of art functions to reproduce social superiority: knowledge or possession of works of art is a mark of distinction, rather than merely a distinguishing mark. This for two reasons. First, since works of art are taken to embody timeless values, an understanding of them is taken as confirming the intrinsic worth, and thus the right to social dominance, of the comprehending beholder. Second, because sympathy with works of art gives vicarious access to the world of self-determining and self-defining activity, and such sympathy confirms the status of the comprehending beholder as one fit to determine and define. Failure to understand art, to participate in the culture which it defines, operates hegemonically in two ways. If understanding art is seen as a good, then failure to understand is humiliating. Learning to understand, in as much as it involves accepting authority, reinforces subordination for one's own good, and in particular reinforces the notion that cultural authorities articulate not particular forms of social hierarchy but eternal values, the values of aesthetic worth. If rejection of art as a good is based on exclusion through cultural and economic deprivation, then it hides the mechanisms of that exclusion, which is perceived by the dominated not as necessity but as choice. If such a rejection is based not on necessity, but on familiarity, it is itself an expression of cultural dominance. Avant-gardism can function in this way, though ruling class philistinisms of various sorts are more usual forms of the phenomenon. It would be possible to argue that this essay's attitude to art is an example of such a strategy for dominance.

The category 'art' with which painters, art critics and historians of art as well as gallery-goers operate is produced and reproduced by them not only as they make, comment on or look at paintings and similar objects, but is produced and reproduced by them and others in the context of commodity production in a corporatist capitalist society. The production

of the category 'art' takes place in school timetables, in different publishing industries, in the physical location and layout of museums and art galleries, in everyday language. Thus historians of art cannot, by modifying their discourse, modify the most significant results of that discourse, the reproduction of the category 'art' and of its hegemonic functions, the naturalization of alienation and the legitimation of social hierarchies. This impossibility is over-determined. It happens first because historians do not control the production of the category 'art' with which they work (as they do, for example, the production of particular categories such as 'significant form', 'Post-Impressionism' or even 'Renoir'). It happens also because as long as they accept the category 'art', their work will only maintain the hegemonic power of the social formation it names.

The ideological power of art derives from its mystification of the process of making, the granting of special status to art making. This entails a concentration, in discourses on art, including historical discourses, on making, production, creativity. The belief that art is the only properly autonomous and self-determining mode of production accounts for the tendency in art historical literature to explain and validate the quality of paintings and so forth by reference to intention, and to regard the significance of a particular object as a function of the way it reflects preconceptions, innovations, or state of mind of its maker. Attempts to divert or purify this mainstream by considering the act of making as a historically located, rather than a heroically private act, seem to me in the end to reinforce the special status of art.

Attempts to show that the production of paintings and similar objects is not mysterious, is not the deposit of genius, inspiration, creativity or any other transcendental quality in the personality or soul of their makers, but is on the contrary determined in ways similar to those in which the production of Mars Bars and washing machines is determined are correct and necessary, but they fail to demystify art. This is because they accept the canon: their account of the working processes of Manet or Courbet acts as an explanation, an addition to

knowledge, within that canon. To locate Manet or Richard Wilson securely in a social and historical context is not to explain the reasons for the special status of those painters within our culture. On the contrary, it takes for granted the whole ideological process of art, the differentiation of art production from everyday production, and the working of the aesthetic criterion as the operative defining characteristic of 'art' from among all paintings and similar objects: thus it can only reinforce that ideology.

Analogies with the history of religion are always tempting when discussing the history of art, and because they are so tempting, they should be used sparingly and warily. But such an analogy may be useful here. While it is possible to write social histories of religion, of patterns of belief, even of martyrdom, it is not possible to conceive of a social history of saintliness. Saintly behaviour is something more than the sum of the pressures, predispositions, expectations, possibilities and constraints which determine the life of the saint. So, under capitalism, with artly behaviour, with the making of a work of art or an *oeuvre*. Monographical social histories of art thus work to confirm the canon, and to re-affirm the special status of art in two contradictory ways. The first is that they confirm the appropriateness of a special sort of exclusive history-writing: any history which concentrates on Manet or Constable as a maker, however much it tries to dissolve the preoccupations of the painter into other social or intellectual phenomena, nonetheless reaffirms that it is the creative personality, the artist, which makes the enterprise worthwhile, and which is the proper study of the history of art, and thus simply reaffirms Gombrich's position. Paradoxically it works also by suggesting – a metaphor from the history of religion again – that God is in the gaps, that such a disaggregation of a creative persona into its historical determinants leaves the fact of individuality, of 'creativity' unscathed, leaves Constable's Constable-ness or Courbet's Courbidity not less but more separate from that which may be explained by reference to history. A social-historical approach can thus work to push the artliness of art increasingly outside time, and thus to reinforce the notion that art is a transcendental value.

Social histories of the making of works of art will thus tend to reinforce the hegemonic power of 'art'. There is another strategy available to historians reluctant to do such work. It is to distance oneself from the exegesis of creativity by concentrating on works of art as carriers of meanings, as vehicles for cultural values, on reception rather than creation.

The carriage of meaning is a complex issue. Art historians tend to approach it using a more or less naive version of reflection theory; works of art are said to reflect the values, ideals, beliefs and ideologies of a particular social group, nation or even 'age', or to reflect social processes or social realities of one sort or another. Reflection theories (and versions of them which say that works of art 'express' such things) are adequate in world-views which see cultural systems as being in an essentially passive relation to the 'real' world. Vulgar marxism is one of these, classical political economy another. For those who think that ideas somehow exist independently of their expressions, reflection theory is unproblematical. For a variety of reasons such simple views are increasingly unconvincing. We have come to view the totality of practices and artefacts which constitute culture (and this inevitably includes those paintings and similar objects which we call 'art') as constituting or constructing value systems, beliefs and ideologies, rather than reflecting or expressing them. As for social processes or realities, cultural forms will mediate them in far from simple ways, ways which will never include reflection or expression. We can now see cultural forms as the space in which people came, and come, to understand the circumstances in which they live, rather than as the space in which such an understanding, achieved elsewhere by another process, is reflected. This is an enormously important restatement. It permits cultural historians to argue that cultural artefacts make the world, as well as being made by it; it gives the cultural form under scrutiny historical as opposed to eternal significance.

However, in the art historical attempt to take advantage of this new position, there remains the assumption that it is works of art, objects which have been selected from a specialized image field on the basis of aesthetic criteria, which should

above all be taken to construct, constitute or carry value systems, beliefs, myths or ideologies. There is no possible justification for such an assumption, though we may be able to identify moments in the past when it was thought to be the case. It is certainly the case that some novels and some paintings have produced and reproduced ideologies and myths more effectively than others, but to say that they have done so because they were works of art is a very odd position to take. One might defend such a position either as a matter of definition, in which case it begins to sound like a theory of social realism, or on the basis that social insight or foresight is an attribute of genius, in which case the position becomes another way of enshrining the special status of artists. Attempts have been made to reconcile the social realist theory of the value of works of art with formalist criteria, but the Goldmannian argument, that there are homologies between the structures of ideologies of classes and those of works of art seems to me to be a sophisticated and elegant, but ultimately sterile, piece of special pleading for the classics.[3]

Thus, to look at the carriage of meaning as the space in which the specialness of works of art is to be explained is once more to reinforce the canon. There is another path, however. This is to regard works of art as special sorts of signifiers, but no more or less special than any other tightly defined and highly institutionalized form of image, such as the advertising poster, the product label or the technical book illustration. In such a view paintings and similar objects have no *a priori* special status as carriers of value systems because they are works of art. Works of art may of course be given such special status within a given society and ideology.

The question for the new art history is plain. In what ways is meaning carried in works of art, and how are the categories through which we experience the world articulated in works of art in ways which differ from those in which they are articulated in other forms of image? This is a difficult question, and one which may lead us not to general conclusions about the invariant functions of 'works of art' but to historically localized partial answers. One of these answers may be that for art

production under industrial capitalism (and arguably in post-industrial societies and under existing forms of European communist regimes also), the specific work of works of art does not take place so much on the level of the meanings articulated in individual works of art, as in the production and reproduction of the category 'art' as a whole. This is not to suggest that distinctions between different types of imagery and the ways they carry meanings can be ignored. The beliefs which can properly be articulated in salon paintings or in etchings, the subjects which can properly be pictured in them, as opposed to those in advertisements or product labels, form a proper subject for enquiry. Within the social formation 'art', of course, such possibilities have varied according to particular institutions, genres, and coteries at different historical moments. Watching transgressions and redefinitions of these norms is the bread-and-butter work of art historians.

From the point of view of writing a history of the way in which images have contributed to the construction of the categories through which we experience the world, that subset of images which we call art has become increasingly unimportant over the last century and a half. It might be possible to argue that in the four centuries before the more or less simultaneous introduction of rotary presses, continuous papermaking, commercial wood-engraving, electrotyping and photography the image-field called art can be taken to stand for the whole field of imagery. This is however surely an overestimate of the importance of 'art' and directly 'art'-derived imagery at any time between 1430 and 1830, and it obscures the differences between 'art' and 'non-art' imagery. Thus there are practical and historical reasons, to do with the evolution of the corpus of available evidence, for thinking that the history of art is an inadequate institution from which to attempt to write the history of ideology articulated by visual material. This essay has however stressed the theoretical problem.

'Art' is itself a powerful ideology, for ourselves and for those for whom we write. We will not be in a position to circumvent or to ignore the workings of this ideology until we have reconstructed the criteria by which we choose bodies of evidence

from which to write histories of ideology articulated by visual material. There are many paths open to us, some of them already well trodden by workers within the domain of art history proper. We can study the evolution of iconographical corpuses, we can study genres, we can study markets, we can study the image-consumption patterns of groups or classes, we can study the institutions within which particular forms of image were produced and consumed, but we cannot give works of art any special *a priori* status in any such study. It should be clear that within the analysis presented here, there is little likelihood of the 'new art history' modifying the role of art, and thus of art history, in social relations. New art history will only renew old art history. Other image histories, both old and new, may have different and more radical potentials, but that matter is outside the scope of this essay.

Notes

1 Much of this essay derives from a reading of P. Bourdieu's *La Distinction: critique sociale du jugement*, Paris 1979 (translated as *Distinction. A Social Critique of the Judgement of Taste*, London 1984) on which I have written a review essay in *The Oxford Art Journal*, Spring 1986. Some of my ideas have been formed in contact with L. Althusser's 'Ideology and Ideological State Apparatuses' published in *Lenin and Philosophy*, London 1971, and some after reading G. Lukacs, *The Historical Novel*, London 1962 (from the Hungarian of 1947, and German of 1955) and L. Goldmann, *Le Dieu caché*, Paris 1955 (translated as *The Hidden God*, London 1964).

When I gave an earlier version of this paper at the Association of Art Historians' conference in 1983, M. Podro made some stimulating criticisms, principally that I had exaggerated the seamlessness of the ruling class, and thus played down the fact that ideologies such as art could be the site of struggle as well as an instrument of control. The

point is right in theory, but wrong as it relates to history of art for a variety of practical reasons. The first is that I take European ruling classes to be less deeply divided than does Podro. They are certainly fractionalized, and different fractions may indeed use different and contradictory parts of the ruling ideology as tools in their own self promotion: but as they do so, the tools they use are unlikely, under most circumstances, to weaken the hold of the class as a whole on power, and the nature of the economic system which produces those classes. Also, my analysis of the ideology of art suggests that the contestatory nature of avant-gardism has become a central part of the way in which the ideology of art is produced and reproduced. That there should be a struggle of a certain sort over art is central to its continued repressive function: Podro supposes that that struggle, while usually ritual, may sometimes become real. And so it may, but this is an unlikely outcome. The same arguments hold with considerably more force when we examine an institution parasitic on art, namely art history. The new art history will renew the old art history in the same way as the new art renews the old art. The changes that will break these spirals of self perpetuation are unlikely to take place within the ideological field and the social formation which is called art.

2 This essay has tried to be self-conscious in its employment of the term 'art'. It has refused to use it as a collective noun, preferring the more longwinded 'paintings and so forth'. Similarly it has tried to avoid 'artist'. Where the socially constructed field termed 'art' is discussed from the outside, the word is given inverted commas, where it is used in standard phrases such as 'history of art' it has been left without inverted commas, and similarly when discussing the way in which the ideology of art functions in society it has seemed disruptive to give the term the distance which inverted commas confer, because the concept as it does its work in ideology is not used in a distanced way.

3 See note 1 for the reference to Goldmann's work. The theory is reproduced and modified in *Pour un sociologie du Roman*, Paris 1964.

Taste and Tendency

Charles Harrison

'The problem of the misrepresentation of the producer in author discourse can be split into: 1) the question of claims explicitly made in interpretive discourse concerning generative (producer) structures; 2) the question of implicit or residual claims concerning such structures; and 3) the question of the blocking effect of author discourse vis-à-vis inquiry necessitated by 1) and 2).'

Art & Language, 'Author and Producer Revisited', *Art — Language*, vol.5, no.1, Oct. 1982.

The Association of Art Historians nowadays requires the resources of a large institution for its annual conference. In the 1950s the total complement of English-trained art historians could probably have been assembled in one large drawing-room. Their refugee colleagues, who had generally been better educated in Germany or Central Europe, might have filled an adjoining study. The supposed 'newness' of recent art history has much to do with the relative novelty of art history itself — and the greater novelty of modern art history — as a substantial discipline or profession. An area of study so newly

and so successfully entrenched in a number of universities and polytechnics is bound to have to respond to developments in those larger disciplines which breathe down its neck; notably history, literature and the social sciences. As it has expanded, art history has been under pressure properly to identify itself as a discipline contributing to the Humanities, both defensively by marking its own boundaries and aggressively by demonstrating some capacity for methodological self-renewal along the lines of current intellectual fashion. It is in the area of modern-period studies that this pressure has been most strongly felt, for reasons which have to do not only with the normal insecurities attendant on studies of the recent past, but also with the specific nature of modernist culture, which has tended to value 'sensitivity of response' over adequacy of theory. All this is more or less what one might have expected.

There does persist, however, a feeling that certain forms of disagreement about the nature of the job have remained specific to art history over a long period of time. These are the consequences, I think, of disagreements about the nature of the subject itself. A 'subject' – in the academic sense – connects a set of objects of inquiry to a set of principles of inquiry. A degree of professional agreement is achieved in the natural sciences, for instance, by the learning of certain shared 'gestalts'. It might seem that the distinctions between the arts and the sciences are well enough known to need no further rehearsal. The study of art faces specific problems, however, which give those distinctions a particular poignancy, and which a 'new' art history, if there is or is to be such a thing, must needs confront. The vocabulary of art history must be adequate to the task of furnishing verbal descriptions for complex phenomenal forms. But the acquisition of relevant definitions in art history is not, as it may be in science, a matter of 'nature and words being learned together' in the face of concrete examples. Works of art are not natural. The tendency of art history has been to represent them in terms of established categories and concepts, as tokens of those cultural values they are supposed to express. The methodological critique of art history is thus necessarily a matter of inquiry into

these categories and concepts and into the mechanisms of their entrenchment; a critique not of the objects themselves, but of the terms in which they have been represented.

According to what has been the dominant view (the 'author' discourse), works of art are identified as such as the embodiments or depositories of an objectively discernible quality. Authenticity is a matter of this quality being traceable to its source in the individual author or creator. The priority placed upon authentication is methodologically inseparable from the value accorded to creativity. This helps to explain the curious combination of dusty antiquarianism with fulsome hagiology which characterizes so much published work in art history. In its epistemological aspect, art history of this colour transmits a set of principles of authentication and a corpus of authenticated work. The study and celebration of such things is seen as potentially civilising in itself and as a means to safeguard and to perpetuate those value systems which are the yardsticks of civilisation.

So far so good. Given adequate powers of discrimination it does seem as if one could know what to learn, how to learn it and why it matters. There is another view, however, (the 'producer' discourse), according to which the objectively discernible quality is a form of misrepresentation behind which attributable interests are concealed. In this account the generation of works of art is best studied, like any other form of social production, in the context of a certain system of production, distribution and consumption. Where the first view presupposes a transcendental and spiritual 'quality' irrespective of contingent interests, the second emphasizes historical changes in value relative to other practices. In its epistemological aspect art history of this second variety is more like social anthropology (i.e. some methodology for studying the meanings and values of another culture) than like connoisseurship (i.e. some supposedly informal practice in which meanings and values are recognised – or constituted). Its concern is not so much with the authenticity of a range of objects as with the ways in which those objects functioned – and perhaps continue to function – within the social, professional, religious

and other structures of a given community. Indeed, the individual 'authentic' work of art cannot be extruded at all without loss of real identity and significance. It seems that what is learned in the first model must somehow be unlearned if the second is to be applied.

It might seem, from the recent promotion of a 'new art history', that socio-historical forms of inquiry have only recently been pressed into service to counter the methods and assumptions of connoisseurship. In fact, relatively exciting though they still seem to be in the field of academic art history, disputes of this general form have been endemic to the intellectual life of Europe for over a century. Even in English-language art history, those versed in the intellectual traditions of the European left or alerted for one reason or another to the resources which those traditions provide, have been chipping away at the edifice of polite art history for at least half a century. (Think of Francis Klingender, Meyer Schapiro on *The Nature of Abstract Art,* and even the Clement Greenberg of *Avant-Garde and Kitsch.*) Previously subordinate in most cultures, the second of our two viewpoints does now appear to be achieving or to have achieved a position of determination upon the politics of modern thought (though not, it seems, upon the reigning thought in politics).

Even if this is so, however, we should not expect that a new rational consensus will be smoothly and gradually achieved. Failing conceptual hierarchies are the more prone to dogmatic and arbitrary entrenchment as their institutional effectiveness is endangered. In the field of art history the stabilizing tendency of relevant institutions is linked to the conventional means of identification and distinction of works of visual art as physical objects with material character. These objects are valuable, marketable, in ways that poems and symphonies are not. All other things being more or less equal, the better, the more authentic the work, the higher its value. The stability of the market and of its hierarchies depends to a large extent upon the stability of a canon of excellence.

Questions of quality and value are supposed to be distinguishable as regards works of art. Nothing points so tellingly to

the fact that they are *not* securely distinguishable as the nervous energy expended by art historians and aestheticians in their attempts to prise them apart. Their anxiety perhaps reflects some insecurity about the legitimacy of art history's own parentage. The art historian can certainly claim some lineage among the developing humanities. It has also to be acknowledged, however, that the relevant professional skills of discrimination and research have been sharpened in the market place among auctioneers and dealers, where authoritative attribution and scholarly provenance are crucial in the establishment of value. The profession of art history is deeply implicated both in the business of an energetic market and in the marmorizing tendencies of a museum culture. The relations of mutual necessity which bind all three together could perhaps be taken for granted – naturalized – so long as the activities of each alike could be represented in terms of the celebration and safeguarding of an ineffable quality. These relations, however, are now open to scrutiny from those who see themselves (perhaps mistakenly) as free on the one hand from responsibility for the upholding of supposedly spiritual values, and on the other from implication in the market place. It was inevitable that this scrutiny would be applied once art history, as a subject and as a profession, grew beyond a relatively restricted social and institutional ambiance. Paradoxical as it may seem, questioning of the canon is a consequence not so much of the radicalization of art history as of its academic expansion and entrenchment along the lines mentioned earlier.

The walls of art history's Jericho are upheld by powerful non-cognitive agencies, however. These are mostly traceable back into the economic sphere. To say this, though, is not entirely to explain the obduracy of certain interests, and of certain forms of valuation. Those inclined to celebrate the implementation of a new order should count the forecasts which have so far gone unfulfilled. Walter Benjamin, for instance, believed that improvements in the technology of mechanical reproduction would lead to relaxation of the criterion of authenticity, to a diminishing of the aura of originality and to

a decisive revaluation of technical categories. There is also
matter for thought in the recent restabilization of painting
and sculpture as curatorial categories – as in 'A New Spirit in
Painting' (at the Royal Academy in 1981) and 'The Sculpture
Show' (at the Hayward Gallery in 1983). It seems all has been
made better again, for the market at least, after the supposed
'dematerialization of the art object' in the later sixties.

At some level the interests of art history must be determined
by the tendencies of art. But it will do no harm if the discipline
of art history has to acknowledge its dirty hands. Nor will the
vocabularies of art history and art criticism suffer from expo-
sure of their typical euphemisms. If the disquisitions of the
civilised can defensibly be represented as the slaverings of the
snob, then so be it. The adulatory monograph is long overdue
a rest, and with it the concept of genius, on the coat-tails of
which a second-hand authority masquerades as humility.
There is much work to be done on the mutual implications of
art history and curatorship; not because the relationship is
necessarily immoral but because the apparent necessity that it
be misrepresented generates falsehood systematically. In the
field of education the indoctrinating protocols of art apprecia-
tion need tracing through all their extensive ramifications.
This will require an art history armed with extreme self-
consciousness about the constitution of value; an art history
which treats the antecedent valuations of art history itself as
the proper subject of its own inquiries.

There are two problems to be borne in mind by those who
now engage with art history. The first concerns the profes-
sional status of the subject and the second and more important
concerns the status of works of art as intensional objects (that
is, as objects characterized by the degree of some quality
associated with them, rather than classified on the basis of
similarity). The two problems are closely interrelated. A disci-
pline which acknowledges its own misrepresentations and
contradictions may appear to be putting its own house in
order and may indeed be doing so. It may also appear ripe for
colonization, particularly by any neighbouring discipline
which has furnished methodological resources for insurgents.

Wherever defences against relativism have collapsed or been undermined, for example, the social sciences have been quick to insinuate themselves. In surrendering the possibility that some objective quality is somehow deposited in works of art – and in far higher degrees in some than in others – art history may surrender the grounds of its own autonomy. In doing so it would, I believe, be denying what is specific and specifically interesting about its own subject matter.

If it can be shown that some powerful necessity has required the mis-representation of value as quality, it still does not follow that the reduction of 'quality' to 'value' is justified in all cases. Quality may just be *one* of the things which value picks out (and that sometimes adventitiously). The two concepts may actually stand in a relation of significant asymmetry. The emotivist aesthetics of Modernism – 'It has to be good because I feel that it is' – does indeed stand in need of explanation and correction. But it remains true that the most interesting and difficult thing about the best works of art is that they *are* so good, and that we don't know why or how (though we may know much else about them). The traditional tendency to mystify and to control this area of ignorance has certainly served some authoritarian and obscurantist ends. But unless we can somehow acknowledge the great importance of this limit on our explanatory systems, we might as well give up. What would giving up be like? I suspect that it would be like becoming a social anthropologist.

Saussure versus Peirce:

Models for a Semiotics of Visual Art

Margaret Iversen

1
Although enquiry into the nature of meaning in the visual arts
has by now a long history, very little has been written on the
fundamental problem of how visual signs produce meaning.
The great exception to this rule is the ground-breaking work
of Meyer Schapiro who has written one article directly con-
cerned with the semiotics of visual art and many others which
imply this approach.[1] Yet a fully developed semiotics of art is
still needed if we are to understand the nature of visual sig-
nification. Such a theory would also provide the basis for an
effective critical and interpretive method like those which
have built upon the semiotics of literature, film and photogra-
phy. A theory of visual signification would have the great
advantage of escaping the traditional and disabling distinction
between form and content, or style and subject matter. Scha-
piro is well aware of this:

> Meaning and artistic form are not easily separated in
> representation; some forms that appear to be the con-
> ventions of a local period style are not only aesthetic
> choices but are perceived as attributes of the represented
> objects.[2]

Semiotics brings with it analogies between language and other

forms of representation. Schapiro has reformulated the notion of style to make this analogy explicit:

A style is like a language with an internal order and expressiveness, admitting a varied intensity or delicacy of statement.[3]

Elsewhere he makes it clear that for him style involves more than formal qualities.

In each style are rules of representation which together with the ideas and values paramount in a culture, direct the choice of position, posture, gesture, dress, size, milieu and other features of the action and objects.[4]

Aestheticizing formalism is one barrier to a satisfactory critical procedure, yet the opposite emphasis on subject matter alone is equally inhibiting.

This latter failing hampers the important work done in the areas of iconography and the psychology of pictorial representation. I am thinking here of those twin pillars of Anglo-American art history, Panofsky and Gombrich. Iconography focuses mainly on the identification and interpretation of mythological and biblical subjects in history painting and sculpture. Panofsky is aware of this limitation and proposes a higher level of interpretation, called iconology, which takes account of all the features of the work. Unfortunately he is very vague about what procedure, other than 'synthetic intuition', this study involves.[5]

Gombrich's approach to the fundamental problems of visual representation in *Art and Illusion*[6] provides us with a theory of how recognizable images are produced and perceived, but recognition is only the first step in deciphering an image. Beyond this we need to know how motifs and their arrangements, together with materials and artistic procedures, are deployed to produce meaningful ensembles. For instance, we may recognize a painting as a depiction of a landscape, but how are we to read what conception of nature or the countryside it represents? For this a psychology of pictorial representation is useless, for we have shifted to the level of

semiosis.

Panofsky and Gombrich form part of a tradition stemming from Kant and Hegel which understands art as a means of bridging the assumed gulf between rationality and the material world, or of retrieving past or alien cultures by subsuming them in our own, or of enhancing the unity and composure of the self. This concept of art ensures a kind of critical and interpretative procedure which values art's incorporation of a mass of detail in a fluent formulation, or which traces historical continuities like the genealogy of motifs, or which seeks the ultimate meaning in a work of art as the reconciliation of conflicting elements. The new approaches to art history are new, and share a common pursuit, to the extent that they begin with a radically different conception of art. Art is no longer regarded as part of the solution but as part of the problem, laden as it is with all the ideological baggage of history be it bourgeois, racist or patriarchal. The new critical procedure, accordingly, involves a thorough-going critique of visual imagery past and present, from paintings to pop videos. Semiotics is one tool among others which can be used to lay bare the contradictions and prejudices beneath the smooth surface of the beautiful.

My purpose here is to indicate very briefly possible models for a semiotics of visual art. One follows the lead of the Swiss linguist Ferdinand de Saussure (died 1913), the other that of the American philosopher Charles S. Peirce (died 1914). They had differing approaches to the science of signs, but both have had a lasting effect on subsequent research. Saussure's ideas have been further developed in the, mainly French, structuralist and semiological analyses of social and cultural phenomena like those of Claude Lévi-Strauss and Roland Barthes. Peirce's work has been enthusiastically received by the distinguished linguist Roman Jakobson who began his career as one of the Russian Formalists, and by Peter Wollen in his *Signs and Meaning in the Cinema*.[8]

It is my view that Saussure and Peirce have strengths in different directions, but that Peirce's system offers a much richer potential for our purpose of formulating a semiotics of

visual art. This is because Saussure believed that linguistics should serve as the master pattern for the study of semiology in general, a view which has the consequence of treating all signs as though they are fundamentally arbitrary and conventional like linguistic signs. Linguistic signs are arbitrary in the sense that there is no relation between the sound of a word and its meaning other than convention, a 'contract' or rule. It is clear that visual signs are not arbitrary, but 'motivated' – there is some rationale for the choice of signifier. The word 'dog' and a picture of one clearly do not signify in the same way, so it is safe to assume that a theory of semiotics based on linguistics will fall short of offering a complete account of visual signification.

Peirce's richer typology of signs enables us to consider how different modes of signification work, while Saussure's model can only tell us how systems of arbitrary signs operate. However, Saussure's stress on arbitrary signs and his insight into how they rely on a systematic play of both conceptual and phonetic differences can inform our understanding of visual signs. Visual signs may be motivated and yet still obey some of the semiotic principles most clearly realized by language. The Saussurean model of semiotics is, in fact, a valuable antidote to the lingering assumption that the relation between the visual sign and its object is a natural and immediate one. The very fact that the whole history of writing on art, from Alberti to Gombrich, has sought to demonstrate the intellectual, abstractive procedures necessary for the production of an image, indicates that it is written against the background of a deep-seated prejudice within western philosophy that iconic images are too close to their objects to have the character of thought and language. Plato's complaint about the mimetic arts was not so much that they are illusory or deceptive, but that they are not suitable vehicles for providing us with knowledge. This is why most apologists for the visual arts, from the Renaissance through the eighteenth century, have tended to valorize design, the intellectual conception of a work, as the invisible 'soul' of painting as opposed to its visible part, its 'flesh and body',[9] and have stressed analogies between paint

ing and poetry or geometry or rhetoric. The analogy with language is another, perhaps better, way of revealing the gap between pictorial representation and its objects.

II

Saussure's main contribution to the science of signs is his demonstration that signs can only operate within systems of difference. Both phonemes and concepts are negatively differentiated from each other. This means that while the pronunciation of a word may vary from speaker to speaker, it maintains its identity as long as it does not overlap with another significant sound in the system. The same is true of conceptual values, since as Saussure observes:

> the value of just any term is accordingly determined by its environment; it is impossible to fix even the value of the word signifying 'sun' without first considering its surroundings: in some languages it is not possible to say 'sit in the sun'.[10]

This is because in some languages the value of the word meanng 'sun' is limited by another word meaning 'the rays of the sun', so the former signifies the heavenly body only. A linguistic unit has a relational identity like that of two 8.25pm Geneva-to-Paris trains that leave at twenty-four hour intervals.

> We feel it is the same train each day, yet everything – the locomotive, coaches, personnel – is probably different... what makes the express is its hour of departure, its route, and in general every circumstance that sets it apart from other trains.[11]

There is a lesson to be learned here about the nature of signification in visual signs, which will help us to guard against the assumption of fixed meanings. Pliny's tale about the painter Timanthes might be recycled in this new context. Painting the story of the sacrifice of Iphigenia, Timanthes 'has exhausted all the indications of grief' on the secondary witnesses, so he decides to paint Agamemnon with his cloak pulled over his face. This solution is offered by Pliny as an instance of

Timanthes's genius. His insight is pure structuralism: given a system of relative values even a blank, an absence, can be eloquent of grief.[12]

The closing chapter of Schapiro's *Words and Pictures*, called *Frontal and Profile as Symbolic Form*, is governed by the Saussurean principle.[13] Unfortunately, however, as with Lévi-Strauss, difference is here reduced to sets of two term oppositions. There is no doubt that binary opposition does play an important role in visual signification, and Schapiro's analysis of the use of frontal and profile as contrastive pairs demonstrates the case.

> In other arts besides the medieval Christian, profile and frontal are often coupled in the same work as carriers of opposed qualities. One of the pair is the vehicle of the higher value and the other, by contrast, marks the lesser. The opposition is reinforced in turn by differences in size, posture, costume, place, and physiognomy as attributes of the polarized individuals. The duality of the frontal and profile can signify then the distinction between good and evil, the sacred and the less sacred or profane, the heavenly and the earthly, the ruler and the ruled, the noble and the plebeian, the active and the passive, the engaged and the unengaged, the living and the dead, the real person and the image. The matching of these qualities and states with the frontal and profile varies in different cultures, but common is the notion of a polarity expressed through the contrasted positions.[14]

Critical theory is here in grave danger of deteriorating into an imposed frame of limitations. The rigidity of the binary opposition with its privileging of one term of the pair is a familiar ruse of power which enforces hierarchies, fixes gender roles and conspires with the politics of exclusion. It is incumbent upon the critic to deconstruct these polarities, rather than to police their boundaries. This determination is at the heart of the post-structuralist project. Terry Eagleton sums up the difference between High Structuralism and Post Structuralism as follows:

Structuralism was generally satisfied if it could carve up a
text into binary oppositions (high/low, light/dark,
Nature/Culture and so on) and expose the logic of their
working. Deconstruction tries to show how such opposi-
tions, in order to hold themselves in place, are sometimes
betrayed into inverting or collapsing themselves, or need
to banish to the text's margins certain niggling details
which can be made to return and plague them.[15]

The difficulties and dangers associated with structuralism are
evident in a passage from *Frontal and Profile as Symbolic Form*.
Schapiro wants to demonstrate the impossibility of ascribing
fixed values; the contrastive pair male/female can serve to
symbolize sky and earth respectively, or earth and sky.

A parallel may be found in the matching of sky and earth
or sun and moon with male and female. In Greek and
other Western traditions, the sky and sun gods are male
and the earth divinity female, as in the gender of words
for sky, sun and earth. But in Japan the Shinto ruler of
the heavens is a woman. Yet neither choice is entirely
arbitrary; we can describe the earth as masculine in its
weight, dark soil and hard rock in contrast to the sky, and
the sky as feminine in its lightness, softness, and variabil-
ity. But one can also proceed from other qualities and
match the earth's receptiveness and fertility with the
woman, and couple the rain-giving, over-arching, sunny
sky with man. In both pairings, as in poetic metaphors,
real qualities of the symbols and the symbolized are
brought out in the contrasting matchings.[16]

For Schapiro, the fact that the symbols are reversible does not
imply arbitrariness. And indeed they are not arbitrary in rela-
tion to patriarchal systems of fixed gender roles which these
symbols serve to naturalize. Schapiro moves too quickly from
signifier to signified, instead of moving across a chain of sig-
nifications locating points of contact with institutionalized
oppression. The post-structuralist would not do that either,
but would begin by pointing out that the binary opposition

marginalizes women as other, as different in relation to the positive identity of man, and then remind us that a positive identity, if one existed, would need no other to secure its standing. The very gesture intended to secure an autonomous identity undermines the position.

III

There are several accounts of Peirce's theory of signs.[17] My purpose is not to rehearse his general theory, but to consider the implications of artists' use or avoidance of each type of sign in the trichotemy icon, index, symbol. These implications are connected with the different relations each type of sign bears to its object. The icon signifies by virtue of a similarity of qualities or resemblance to its object. For example, a portrait iconically represents the sitter. The index signifies by virtue of an existential bond, in many cases a causal connection, between itself and the object. For example, a weathervane indexically signals the direction of the wind; a footprint indicates that someone has been on a beach. The symbol signifies by virtue of a contract or rule – it is the equivalent of Saussure's arbitrary linguistic sign. Since for Peirce the sign relation is triadic, each of these signs bears a different relation to the interpretant as well as to the object. The tenuous, conventional relationship between sign-vehicle and object characteristic of the symbol relies upon an interpretant who knows the rule. To put it another way, there is an intrinsic dependence on the mind for there to be any relation at all. The opposite is true of the index. Because the sign vehicle is physically connected to its object, the interpreting mind has nothing to do with that connection except in noticing that it exists. Indexical signs don't depend on conventional codes to establish their meaning. The icon would appear to have a certain independence with respect to both object and interpretant.

> An icon is a representamen of what it represents and for the mind that interprets it as such, by virtue of its being an immediate image, that is to say by virtue of characters which belong to it in itself as a sensible object, and which

it would possess just the same were there no object in nature that it resembled, and though it were never interpreted as a sign.[18]

Peirce isolates two sub-categories of the iconic sign, images and diagrams. The diagram, unlike the image, does not resemble the 'simple qualities' of its object but only the relations of its parts. The notion of diagrammatic aspects of visual images is particularly helpful in a semiological critique. To take one striking example, Masaccio's *Trinity* diagrammatically sets out the hierarchical relations of the figures represented, from God the Father at the centre and top of the field to the kneeling donors at the bottom and periphery. The superimposition of Father, Son and Holy Ghost is a diagrammatic expression of the Three-in-One. Hierarchical arrangement pervades representation. Many double portraits show a standing husband and seated wife. The official engagement photograph of Prince Charles and Diana had the couple discreetly ranged on stairs so that Charles would appear taller than his fiancée. The orientation of perspective construction can also act diagrammatically; as John Berger once remarked, we look up at princes and down at nudes. Contemporary art offers much material for an analysis using Peirce's typology. This is because of its flight from the most familiar type of visual sign, the image.

High Modernism in the form of Abstract Expressionism is the apotheosis of the indexical sign or all-over signature. It uses the contiguity of the index to point back to the presence of the artist. This perhaps helps to explain the personality cult which surrounded Jackson Pollock. Yet there is another use of the index which reduces the gesture to an absolute minimum to set in train another series, for instance, clicking the shutter release of a camera or positioning a ready-made in an art context. Rosalind Krauss has written about Duchamp's preoccupation with the index.[19]

The Duchampian use of the index was to re-emerge in the mid-fifties as a critique of expressionism in the work of Jasper Johns. His work can be read as an exploration of modes of

signification other than the image. Johns's self-consciousness about representation has been noted by Barbara Rose who refers to his interest in Duchamp, Magritte and Wittgenstein,[20] but her article betrays an uncertainty about different modes of representation, in particular the fact that the non-use of the image is likely to spill over into either indexical or symbolic signs. And this is exactly what happens in Johns's case.

Johns's use of pre-figured conventional designs such as flags, targets, numbers and letters of the alphabet – all symbols in Peirce's sense – seems to mock the vaunted freedom of the artist. His use of mass-produced objects, stencils and cast fragments of the body has the same effect. Many of his iconographical motifs, a canvas face down or the front panel of a drawer glued fast to a canvas, also suggest a critique of the possibilities of representation. His art is an abnegation of the artist's privileged access to depth, interiority and ultimate truths – a critique of the role of the artist carried forward by Minimalism. The relentless negativity of Johns was no doubt necessary to clear the air of metaphysical cant which surrounded Abstract Expressionism, especially the importance that was attached to the unique individuality of the expressionist gesture. Johns's use of symbols and mass-produced objects seems particularly pointed in this context. Peirce wrote about how symbols elude the individual will.

> You can write down the word 'star', but that does not make you the creator of the word, nor if you erase it have you destroyed the word. The word lives in the mind of those who use it.[21]

Perhaps Johns's close friend and colleague, Robert Rauschenberg, was drawing attention to the presumptuous individualism of his predecessors' art when he erased and exhibited a de Kooning drawing.

IV

In recent years, particularly in response to the woman's movement and to the writing of Lacan, interest in the structuring of subjectivity and its role in ideological oppression has been intense. One artist who has responded to this project is Mary Kelly. It is fitting that I should end with a reference to her *Post-Partum Document*, since it was there that my interest was kindled in the non-use of the image and its implications.[22]

Kelly speaks of a division in her work between her lived experience as a mother and her analysis as a feminist of that experience. These two sides of the project are signalled by the use of indexical signs, on the one hand, and symbols, on the other, set in montage-like juxtaposition. The mute, sensuous traces (moulds, stains, fragments of blanket) are related to the sense of touch, to the Imaginary identification with the child and to the pleasure of mothering. The diagrams and abstract scientific discourse serve two purposes. They allow a distance from the mother's fetishistic attachment to her child, a salutary release from immediacy. But they also almost parody the abstraction of the symbolic order and self-consciously witness women's difficult, estranged relation to language within patriarchy. Kelly draws out the potential connotations of Peirce's typology of signs: the intimacy or urgency of the index in relation to its object and the remoteness of the symbol necessary for contemplation.

Mary Kelly's non-use of the image is as rigorous as Johns's, but it is differently motivated. It is a recognition that, at present, it is impossible to represent women iconically without that image succumbing to cliché, appropriation, fetishization. Perhaps the iconic sign's long historical association with the power of the gaze and its simultaneous reception as reflection of the real, make it, for a politically self-conscious artist, a particularly dangerous, insidious, mode of representation.

The new art history is equally suited to the critique of traditional modes of representation, as it is to the elucidation of contemporary oppositional art which is itself an inquiry into the ideological implications of the sign.

Notes

1 See especially, Meyer Schapiro, 'On Some Problems in the Semiotics of Visual Art: Field and Vehicle in Image-Signs', *Semiotica*, Thomas Sebeok, ed., vol.1 The Hague 1969, pp.223-242.

2 Meyer Schapiro, *Words and Pictures: On the Literal and Symbolic in the Illustration of a Text*, The Hague 1973, p.37.

3 Meyer Schapiro, 'Style', *Anthropology Today*, A.L. Kroeber, ed., Chicago 1953.

4 Schapiro, *Words and Pictures*, p.12.

5 Erwin Panofsky, *Studies in Iconology: Humanistic Themes in the Art of the Renaissance*, New York 1962, especially 'Introductory', pp.3-32.

6 Ernst Gombrich, *Art and Illusion: a Study in the Psychology of Pictorial Representation*, Bollingen Series XXX.5, Princeton 1970.

7 Schapiro, 'On Some Problems', p.223.

8 Peter Wollen, *Signs and Meaning in the Cinema*, London 1969.

9 Louis Marin, 'Toward a Theory of Reading in the Visual Arts: Poussin's *The Arcadian Shepherds*', *The Reader in the Text: Essays on Audience and Interpretation*, S. Suleiman and I. Crosman, eds., Princeton 1980, p.301.

10 Ferdinand de Saussure, *Course in General Linguistics*, Charles Bally and Albert Sechehaye, eds., Glasgow 1974, p.116.

11 *Ibid.*, p.108.

12 Pliny, *Natural History*, Book XXV.

13 Schapiro, *Words and Pictures*, see footnote 2.

14 *Ibid.*,p.43.

15 Terry Eagleton, *Literary Theory*, London 1983, p.4.

16 Schapiro, *Words and Pictures*, p.48.

17 The best primary source for Peirce's theory of the sign is 'Logic as Semiotic: the Theory of Signs' in *The Philosophy of Peirce*, J. Buchler, ed. Secondary sources include D. Greenlee, *'Peirce's Concept of the Sign*, The Hague 1973,

and D. McNeill, 'Pictures and Parables', *Block,* 10, 1985, pp. 10-18.

18 Peirce, 'Logic as Semiotic'.
19 Rosalind Krauss, 'Notes on the Index: Seventies Art in America', *October*, 3, Spring 1977, pp. 68-81.
20 Barbara Rose, 'Decoys and Doubles: Jasper Johns and the Modernist Mind'. *Arts Magazine,* vol. 50, 1975-6, pp. 68-73.
21 Peirce, 'Logic as Semiotic', p.114.
22 M. Iversen, 'The Bride Stripped Bare by her own Desire: Reading Mary Kelly's Post-Partum Document', *Discourse*, Winter 1981-2, pp. 75-78. Reprinted in Mary Kelly, *Post-Partum Document*, London 1983, pp. 206-209.

This paper was written in preparation for a book on the semiotics of visual art.

Photography, History and Writing

Ian Jeffrey

At the end of a savage incursion into the quaint old world of calotype history Christopher Phillips proclaims a new historical utopia: 'Especially in historical and literary studies, profound changes have been wrought by the realization that the same terrain may be differentially "scanned" by means of analytic and critical techniques drawn from a number of specialized disciplines – linguistics, sociology, semiotics, rhetorical analysis, and psychoanalysis, to name but a few'. Art history, with photography history as a blameworthy accomplice, lags behind carelessly and constitutes a professional scandal. It is true that state-of-the-art analyses hardly occur in photography history; but, on the other hand, can they be expected in a terrain which is largely incognita?

Phillips's article, published in the Fall issue of *October*, 1983, opens up the field. He reviews recent enquiries into early calotype history, an area much surveyed by curator-historians keen to align early paper prints with print-making in general. He begins by revealing photography history as a tendentious business improvised by curators and collectors. He is not sympathetic to these improvisers with their 'slim' essays and respect for the 'ineffable'. In particular he finds fault with the

idea that the early French calotypists were spontaneous, intui-
tive romantics whose paper prints were intended to be affec-
tive and mnemonic, in the manner of sketches and litho-
graphs. Nonsense, he concludes: they have little to do with
private meditation and poetic intuition, and a lot to do with 'a
retracing of already-constituted cultural signs'. As he points
out, many early photographs are of art works, of statues,
drawings and engravings. But he concludes guardedly: 'From
this point we might begin to reassess photography as a tech-
nological mode of social commemoration, an economy of im-
ages circulating and exchanging the signs of culturally sanc-
tioned "ideal power"'. It looks in this case as though a plethora
of specialized techniques has meant that the actual work of
photography history can never be taken in hand.

At one point Phillips notes in passing that 'an astute approp-
riation and orchestration of photographs from the same
period, and often by the same photographers, can land equal
credence to very different critical/historical hypotheses'. His
remark touches on an attempt by Peter Galassi to demonstrate
the continuity of a sketch aesthetic from the art of the 1830s
and earlier into photography in the 1840s. But any attempt to
argue from morphological likeness can easily be falsified,
especially if the hypothesis in question has totalizing ambi-
tions. Photography in its primitive stages is notoriously prom-
iscuous, apparently arbitrary from one moment to the next.
Phillips's own carefully phrased notion concerning the cir-
culation and exchange of 'the signs of culturally sanctioned
"ideal power"' could be challenged as effectively in its turn by
pointing to the many early photographs which seem to have
no subject other than visibility itself, expressed in arrange-
ments of whatever came to hand in the gardens and work-
shops of the 1840s. Theory allows a way upwards and out of
this mess of residues. Phillips cites current preoccupations
with the 'inevitable shaping power of the historian's general
presuppositions and specific research methods'. Yet those re-
sidues stay in place and continue to pose their questions.

One of the images printed and then overlooked in Phillips's
essay is a photograph of 1852 called *Landscape with Farm Tools*

by Eugene Cuvelier. We are advised to pay attention to semiotics, and early photographs reward semiotic attention. The farm tools are a plough and a harrow, implements of winter and spring respectively. They are signs of the seasons, and may even stand for them, but if they do so it is in a very practical, indexical way. Cuvelier's image of the seasons is hardly poetic; like many other photographs of that time it has an orderly, carpentered look which suggests that it might be dismantled or taken as a model. Early calotypists in Britain achieved the same sort of look, both in landscape and in still-life arrangements. If photography is analysed in genre terms borrowed from painting history it appears as nothing better than an amateur extension with its own odd versions of still life and landscape. Semiotic analysis dissolves those categories, and makes it possible to associate these instrumentalist arrangements with, for example, earlier drawings by J.S. Cotman of wheels, windlasses and implements. Cotman's precise neo-classical manner with its accentuated display of modes of representation also foretells the photography of the 1840s and 1850s. Under these terms the so-called primitives appear rather as latecomers in a well-established mode of observation than as pioneers. As a consequence it could be asked, with some justification, why the idea of photography history should be pursued. Surely it would be more suitably placed in a general history of representation? At the moment it is associated parasitically with the major tradition, as continuing this or that tendency in the finer arts. But, as in Cuvelier's case, what happens is far more complicated, as well as less honourable: photographers build on an instrumentalist idiom used informally by painters as draughtsmen. Then, to follow that particular episode through, they switch to a transcriptive mode of representation in the 1850s in which material appears in something like its original state, as presence rather than as sign. Seen thus as having a self-contained history of its own, photography seems subject to baffling and sudden changes of direction, only to be unlocked by a master code yet to be developed. Historians who associate this erratic history with romantic sketching, picturesque formulae and even with

instrumentalist drawing idioms domesticate photography, mitigate its strangeness. Perhaps it was invented and developed in an opportunist context in which what mattered was its flexibility and responsiveness. From the outset it may have been the medium of the empty signifier.

A 'history of photography' verges on the unimaginable. Such a history, if meant to be comprehensive, would be bewilderingly tangential and discontinuous. Styles appear to emerge from nothing, or to draw from literary rather than from pictorial practice. They disappear as quickly, are misunderstood, or are accidentally influential. Photography never lent itself readily to progressive narrative, to totalizing history, or to any sort of Great Unfolding, and in the general histories is always forced into shape, arbitrarily connected. Its great attraction for historians is as a frontier zone where riches might be struck in unlikely ground by passing opportunists, or lost by specialists where all the signs look right. It is marginal land where almost anything goes, where homologies have not yet been discredited, and the influence of the Greimas/Rastier semic rectangle scarcely felt. In it Christopher Phillips and other law-enforcement agents walk heavily girded with theory, reference and the latest metaphors – history, for example, as a terrain to be 'scanned', laser-like.

Most run-of-the-mill photography history is written in explanatory or causalist terms. Until recently it was the preserve of collectors and curators intent on establishing a canon of prime works, and as a consequence its premises and methods have been borrowed from fine art and connoisseur history, with all that entails of respect for individual images. It seeks especially to establish basic data concerning authorship and technique, and holds that the job has been well done if in the end it has been possible to name the instigators and to identify their ostensible purposes. A satisfactory piece of causalist history might, for example, show that photographer *x* worked in Egypt on two occasions in the 1860s, that he used plate and stereoscopic cameras, that he marketed his work in a variety of forms over several decades, and that the pictures bear some pictorial relation to established topographical formats.

Explanatory history is characterized by arbitrary limitations. Its questions concern origination and are phrased with reference to available documentation. The result is a closed, purely 'photographic' history. In the short term it has its roots in patronage history, with publishers, agents and collectors taking the place of grandees. In the long term it depends on the instrumentalist reasoning of positivism, and on examples drawn from the natural sciences. Once documentary evidence runs out speculation enters in, and that explains nothing; moreover, there is a reassuring certainty about contracts, sales figures and the enabling powers of technical development.

Explanatory history has drawbacks. In practical terms it can easily become unmanageable. If it is to work at all it has to be focussed quite narrowly. For example, x in Egypt produces books of the pyramids and of other famous ruins, and that iconography can be explained by reference to his precursors in Egypt who also represented pyramids and temples. But as soon as the artwork is further defined explanation becomes more difficult. Imagine that the artist in Egypt both took pictures and wrote texts. In that case, what exactly is the work? Is it constituted of a series of pictures in relation to a sequence of writing? And perhaps the images themselves show some unprecedented ratio between architecture and the human figure. If that sort of analysis is undertaken the likelihood of a satisfactory explanation recedes almost to a point of impossibility.

It is worth noting with reference to the difficulties of explanation that extended definition seems to exorcise the need for explanation. If a historian looking at x in Egypt could identify particular relationships between, say, texts and images or figures and architecture that in itself might be sufficient. Sufficient for what? Photography (and art) history, despite the comprehensive burdens wished onto it by zealots, is a particular kind of history, meant to keep the past in mind or in play, and it might do that as well by deploying a complete pack of lies. That way lies madness. To put it differently: the merit of an artwork is usually recognized long before its text in history is written, but a text of some sort is always necessary,

and that text has to be written with whatever materials come to hand. Institutional historians discussing the rise of photography suggest curators' and dealers' ramps through which worthless material is given old master status. These accusations are made, as in Christopher Phillips's writing, on the basis of easily falsified support writing, as though the writing preceded the perception of worth. If so-and-so makes sonorous claims on behalf of Cuvelier or Le Secq the truth is more than likely to lie in the sonority than the details of the claim.

But to return to the drawbacks. Most seriously, explanatory history leads to little deepening of historical consciousness. It gives priority to explanation of origins, and is predicated on a notion of inevitability: the artwork was produced with good or some reason. The good reasons include intentions held by artists and their affiliates. But where these intentions are concealed, kept back or submerged, explanations become impossible, at least within positive terms. Then the only option is to speculate or to try to understand.

History which aims at understanding, works through empathy and has its own range of flaws. The positivist historian who deals in measurement, medium and documentation gets down to basics and can hardly be denied. Understanding, on the other hand, depends on intuition and that posits an elite of historians able to sense meanings in the past, able to go beyond proof in commonly held terms. History of this kind produces no transferable assets or common property; it often bears witness as it clarifies, and can amount to a re-enactment in prose of the art under consideration. Mike Weaver's recent writing on Julia Margaret Cameron both points to and embodies the cultural complexity of her milieu. Alan Trachtenberg, in his many articles on the artist, reworks a prose version of Walker Evans's fastidious art.

Re-enactment is a feature of photography history. It is a literary rather than a forensic history. In his article on calotype research, Christopher Phillips quotes Norman Bryson on mainstream art history as the 'leisure sector of intellectual life'. We are meant to be dismayed, but history writing is a matter of instinct as well as of rationality. The material under considera-

tion elicits a fitting response, and if that eliciting goes unheeded the material is expunged rather than enhanced: Phillips's own juridical style quickly pushes his calotype subjects into obscurity.

One of the medium's prime exhibits is Helen Levitt's *A Way of Seeing*, a photo-book on street life in New York City, first published in 1965 with an introduction written by James Agee in 1946. Agee's text is extraordinarily eloquent; this is what he writes of the first picture in the series: 'The intuitions of a child with chalk have so utilized a stamped tin wreath as to create a female head which could also be an image of the sun or the moon; and, as a magnet beneath paper aligns a scatter of iron filings, it commands every disparate element within the frame of the photograph'. An expanded version of the book was republished in 1981 and, after being omitted from most photographic histories, it was considered at length by Max Kozloff in a collection of 1984, *Observations: Essays on Documentary Photography*. Kozloff continues what Agee began. He writes history of a sort, noting, for example, that the physical demonstrativeness registered by Levitt is a particular feature of that city with its largely Catholic and Jewish population. Mostly he shows how the pictures might be understood, writing from his own lived experience in the city's streets.

In the same collection Alan Trachtenberg discusses Walker Evans's *American Photographs*. Trachtenberg, like Kozloff a virtuoso of the common language, uses neither an identifiable procedure nor a specialized vocabulary. He writes with a philosopher's care for definition and judgement. As a historian he is a Pyrrhonist, not caring very much to speculate on unstated intentions. A reader curious about the place of *American Photographs* might have looked for something on the book's relation to the image cycles of Rivera, for example, or to documentary film in the 1930s. What is given is a scrupulous account of the interrelationships of six pictures in a sequence.

Photographs imply and await their texts. They remain, in some radical sense, unfinished; and this is so even when they have been textually invested: the material for *American Photographs*, for example, was gathered in the early 1930s, the book

published in 1938, and only adequately completed or under-
stood in Trachtenberg's writings of the 1970s and after; and *A
Way of Seeing* has elicited two major texts over forty years. In
part this inexhaustibility is due to photography's ontological
obscurity, which means, for instance, that Helen Levitt's New
Yorkers of the 1940s play forever in the streets.

 There is neither agreement as to what constitutes the photo-
graphic canon nor as to how it should be treated. In the most
recent large-scale survey of photography in the U.S., *American
Photography: A Critical History*, Jonathon Green doesn't even
mention Helen Levitt's *A Way of Seeing*, yet devotes a whole
chapter to Robert Frank's *The Americans*, a book of eighty
three pictures authored by a Swiss and originally published in
Paris in 1958. Green's interpretation of Frank's book says
much about photography history. He writes like a polemicist
for whom the photographs are far from dead: '*The Americans*
shows the quest for the values of the ideal life translated and
relocated in commercial advertisements, on billboards, and in
store windows at the roadside. The sacred has become totally
secular. In *The Americans*, the spirit, the quest, tawdry advertis-
ing, and the road have become one. Religious rites have been
usurped by public signs'. He writes like Whitman and his suc-
cessors through to Jack Kerouac, who wrote the introduction
to Frank's book. The understanding lies in the detailed, appo-
sitional style, quite as much as in anything observed. Frank is
nominated as a truth-teller, and the writer doubles as a
preacher: 'The few moments of genuine energy he perceived
within America were distinctly un-American. They came
from a world beyond conventional expectations and attitudes,
beyond the narrow alternatives offered by the establishment's
culture. They came from the vitality of America's sub-cultures
and countercultures...'.

 Green's procedure is to establish Frank as a major artist in
particularly American terms, and then to announce him as a
major influence, thus eliding American photography with a
national aesthetic. Against his evolutionist view it might be
argued that the photographer was a tradition-conscious Euro-
pean artist interested in the book as an art form, and engros-

sed by some of the technical difficulties of naturalism. As the historian remarks, Frank was a critical observer. The picture chosen for the front cover of the edition of 1969 shows a trolley bus in New Orleans, its five windows in sequence, framing from left to right, a white man, a white woman, two white children, a black man and then a black woman. It encapsulates racist and sexist arrangements in a southern city in the 1950s, and its point was probably taken by those who originally saw the book as an attack on the US; yet this most deliberate of images is foregrounded in 1969, as though its element of uncomfortable social disclosure had been forgotten or overlooked. The picture discloses, but rather remarks on an arrangement than declares any social sympathies. This studious side to Frank's art is completely without sequel in American photography.

In New York City he photographed children clustered around a juke box in a candy store; 'blinds' reads an inscription on the far wall, and the frame of juke box makes an arrow head pointing into the closed eye of an auditor; another child mimics, with his empty hands, the gestures of a trumpet player. Such an elaborate interaction between words, emblems and imitative signs and an absent subject, music, is more characteristic of naturalist painting in the nineteenth century than it is of photography in the twentieth. A macro-history of representation might chart the recurrence of such devices in naturalism, and note a tendency in the transcriptive mode to focus on the non-visual, on noise, touch and taste. Seen in this light what is remarkable about Frank's art is not just his broadening of photography's iconographic range to include café furniture and motor culture, but his treatment of this pop-cultural paraphernalia as bearing directly on the senses. To most of his successors things of this sort function symbolically, and usually with respect to alienation and mediated experience.

Green is right when he asserts that *The Americans* haunted the imagination of photographers in the 1960s, and that it can look like the way the poetry of Alan Ginsberg reads. But if the book was influential it was so in a general rather than in a

particular sense – and surprisingly uninfluential in many of its most interesting respects. In its heyday the book was subject to the sort of reading elicited by Beat poetry, which effectively screened out many of its formal and analytical properties. If this is so it suggests the importance of misapprehension in the arts.

There is no obligation on photography historians to prove themselves adepts in state-of-the-art analytical techniques; but monomethodologies give limited access to complex artworks. Photography is well provided with such enigmas. Willy Ronis's book *Belleville-Ménilmontant* makes no impression at all in histories of the medium. It was first published in 1954 and re-published, with alterations, in 1984. It looks, at first sight, like an account of a French suburb still in the grip of post-war austerity. French photographers of that generation were adepts with visual tropes, able to mix metonym with metaphor, to signal a tree by the shadows of its leaves and a pissoir by a storm drain on the edge of a pavement (with reference to a photograph by Izis in *Grand Bal du Printemps*, Lausanne 1951). In 1954 Ronis shows a child's head picked out by an unauthored sunbeam in the shaded Rue de Soleil and a workman carrying a luminous window frame up a sunlit street. He submits the actuality of the street to a play of intellect, re-tells and re-names. In this respect he uses a photographic mode established in the 1920s by André Kertész and subsequently developed by Henri Cartier-Bresson. It is an oblique, secretive idiom which demands that photographs should be deciphered, like conversation among intimates who have come to a certain understanding.

If conversation is an important element in Ronis's art, what does it relate to? He most insistently evokes the physical hardship of life in that suburb built on a hill and crossed by arduous sets of steps and railings. He has exercised his wit among hardships which extend from a strenuous uphill walk to death itself. Without an analytical scheme which allows for structural arrangements in a work of art and for the presence of contradiction and difference, Ronis's book remains a purely transcriptive account of life in a Parisian suburb. The

photographer invokes language and evokes physicality in the early 1950s; his preoccupations run parallel to those of Sartre in the sense that he connects cognition, the recognizing of signs, to an imagery of effort: his suburban people must labour, but the evidence of that labour can only be read, in a pictorial language which is like play. The difference between this and earlier photography in the troping mode is that where the earlier art of Kertész, for instance, lays a stress on reading itself, Ronis's art sets that reading against an effortful ground.

At one level *Belleville-Ménilmontant* is a regional picture book to be explained with reference to a long-standing tradition in popular publishing. Its idiom draws on conventions established by a coterie of photographers in the 1930s – an idiom which is far from popular. At a deeper level the book embodies some of the phenomenological concerns of French philosophy in the 1940s and 1950s. Without structuralism's notion of the symbolic negotiation of contraries, without Lucien Goldmann's idea of homologies, and without Foucault's concept of the episteme, *Belleville-Ménilmontant* might be at a loss for words, a mere transcriptive survey.

Notes

Max Kozloff's essay, 'A Way of Seeing and the Act of Touching: Helen Levitt's Photographs of the Forties', appears in *Observations: Essays on Documentary Photography*, David Featherstone ed., Carmel 1984, pp. 67-80. Alan Trachtenberg's essay, 'Walker Evans' America: A Documentary Invention', appears in the same collection, pp. 56-66. For other photography texts by Alan Trachtenberg see 'Walker Evans's, 'Message from the Interior': A Reading', in *October*, no. 11, Winter 1979, pp. 5-29, and 'Albums of War: On Reading Civil War Photographs', in *Representations*, no. 9, Winter 1985, pp. 1-32. Christopher Phillips's article, 'A Mnemonic Art? Calotype Aesthetics at Princeton', is published in *October*, No. 26, Fall 1983, pp. 34-62. Mike Weaver's *Julia Margaret Cameron, 1815-79*, was published at Southampton 1984.

The Landscape of Reaction:
Richard Wilson (1713?-1782) and His Critics

Neil McWilliam and Alex Potts

Introduction

The controversy which surrounded the Tate Gallery's 1982-3 exhibition of the eighteenth-century landscape painter Richard Wilson appeared simultaneously vaguely ridiculous and profoundly important. In the present article, originally published in *History Workshop Journal* in 1983, we sought to analyse the issues at stake in this extraordinary outburst of political hysteria in the national press and organs of the art trade over an event that would normally be seen as falling right outside the political arena. The exhibition itself was a conventional one man show of oil paintings and drawings by the so-called father of English landscape painting, who up until this point had suffered rather from neglect than controversy. Precisely how – and why – the scholarly catalogue by the Canadian art historian David Solkin ever came to the attention of the national newspapers in the first place is somewhat mysterious – catalogues very rarely rate even a mention in press reviews. We thus felt it important to work out why this particular catalogue, aside from its sheer weight – heavier than either of the recent Turner and Constable exhibition catalogues – should have touched such a raw nerve among journalists and art critics. Denunciations came not just from

the thrusting new right (a *Daily Telegraph* editorial), but also from the old right and from some well-placed critics of more liberal persuasion.

It should be stressed at the outset that what was at stake was not the novelty of David Solkin's approach. A social historical account of the visual arts of the kind found in his catalogue, though not in any way the norm, has been with us for some time now. Solkin could be said to be working within a marxist tradition that goes back at least as far as such 'classics' as Frederick Antal's *Florentine Painting and its Social Background* (London 1948 – still arguably the most ambitious and comprehensive social history of an artistic tradition) and Francis Klingender's *Art and the Industrial Revolution* (Noel Carrington and the Curwen Press, 1947). At the same time, Solkin's contribution clearly belongs to a new wave of left or radical study of the visual arts that got under way in the 1970s, even if he did not appear to share in a growing paranoia among left intellectuals over being labelled a 'vulgar marxist'. His study of Wilson is clearly motivated by the desire to make a concrete political intervention. By contrast, there is a tendency now to react against earlier marxian models of art and society and to insist that art does not reflect social and political meanings constructed elsewhere in the maelstrom of 'real' class struggle, but rather is itself formative of such meanings. Many self-avowed marxists would hesitate to imply, as Lukács was inclined to do, that art or culture are somehow less real than those supposedly more 'materialist' areas of social practice which constitute the economic base of society. These developments in left theory are now being registered in respected academic journals and publications emanating from institutions of higher education, and there is a price to pay. As ways of going about the study of art and culture, they become little more than new methods existing alongside the established practices they once sought to challenge. To put it crudely, they function not so much as oppositional politics as another possible instrument of academic advancement.

In addition to the more specific precedents for Solkin's work in scholarly publications on eighteenth-century British

art mentioned in our article, there is also a whole spate of historical books and articles on eighteenth and early nineteenth-century British society produced over the last twenty years or so that would no doubt be characterized by the average *Daily Telegraph* reader as marxist subversion, but which nevertheless have become standard texts in higher and even secondary education – books such as E.P. Thompson's highly influential *The Making of the English Working Class* (Harmondsworth 1968). It is the sort of view of eighteenth-century British society presented in these texts, one that clearly gives the lie to cosy notions about some harmonious golden age of the benevolent and cultivated Georgian gentleman, that Solkin takes as the historical basis of his interpretation of Richard Wilson. So why the fuss?

The problem was not so much David Solkin's approach as the context in which it was presented. His book had to serve as the catalogue for a prestigious old master exhibition held at a major national gallery; and it also happened to come just at a time when both the English political right and social democratic centre were at their most militant and hysterical over so-called 'marxist extremism', and, more specifically, over what they saw as the need to fend off recent inroads made in English culture by the left. It was at this moment that we were treated to public musings on the educative purpose of English history by such Tory luminaries as Hugh Thomas, Paul Johnson and Lord Blake, who wished to restore a celebratory and patriotic valuation of the nation's past. Even rather faded cultural treasures, such as the English enjoyment of landscape, and the supposed taste and refinement of the Georgian era, had to be defended if challenged on territory where they still seemed vaguely credible.

Our article was very much an occasional piece, so what relevance does it have two or three years on? So far, there have been no repeat performances. And any direct impact, in terms of increased censorship of major exhibitions and their catalogues, is hard to assess. It may be only coincidental that in the catalogue of the next large exhibition held at the Tate Gallery devoted to an early English master, George Stubbs – this time

sponsored by United Technologies of cruise missile fame – talk of class distinctions is nicely qualified. We are reminded, for example, that in Stubbs's portrayal of the lower orders, 'we seem to sense that acceptance of things more or less as they are which was probably characteristic of most working-class people in the eighteenth century'. (United Technologies' chairman writes in the catalogue how he 'is pleased to support the scholarship that provides such fascinating insights'.) More important, perhaps, than speculating on such relatively imperceptible changes is the need to stress certain continuities. If the art establishment and the cultural right have not had to launch another major offensive on this front, the dividing line between different areas of art history and art criticism signalled by the Richard Wilson controversy remains very much in place, and if anything has become more marked – the divide between the world of museums, criticism and the art market on the one hand, and that of academic art history and cultural studies on the other, which Solkin apparently transgressed. Whatever the interest in the social history of art and new theory in academic circles, museums and commercial art galleries generally remain wedded to the traditional old master exhibition that celebrates and documents the work of a recognized great artist. The 'promotional' catalogues accompanying these shows need, implicitly or explicitly, to present the appreciation of high art as transcending political interest and social conflict.

What looked in the 1960s and 1970s to be hints of a move towards a more democratic presentation of works of art, away from elitist and conservative notions so pervasive in the visual arts, have proved rather transitory. Safer values and attitudes are 'in' as far as the more established museum curators and exhibition organisers are concerned. The public, we are told, likes the old mythologies of art, is attracted by uncomplicated ideas of art as treasure or beauty, and doesn't want its enjoyment disturbed by troublesome questions about sex or class. But then who would even have given a second thought to Richard Wilson if David Solkin hadn't engaged with the political meanings of his art? Who otherwise, aside from a few

specialists, would have felt this sort of painting raised issues that could matter in any significant way? Without a potentially disruptive politics lurking somewhere, the idea of pure aesthetic delight in masterpieces of art remains a pretty feeble and insubstantial ideal, hardly worth asserting, let alone defending. Maybe the art establishment really ought to be grateful to David Solkin after all.

The Landscape of Reaction:
Richard Wilson (1713?-1782) and his critics

Traditionally in this country, the Right's refusal to recognize the politics implicit in high culture has been expressed in hurt accusations against the Left for dragging politics into culture. But times are changing. The Right has now moved to the offensive, sniffing out the slightest hints of marxist subversion. Nothing showed this more graphically than the acrimonious, and on occasion frankly hysterical, attacks on last autumn's Tate Gallery show devoted to the eighteenth-century Welsh landscapist, Richard Wilson. A visitor might easily have wondered what all the fuss was about – room after room of landscapes, so classicizingly ideal to modern eyes that the British scenes were almost indistinguishable from the Italian ones, tastefully arranged in chronological order; was this not the standard kind of tribute the art world now pays to a slightly neglected old master like Wilson? The walls were free of didactic placards, the paintings simply allowed to 'speak for themselves'. The one intrusion, so discreet as to be barely noticeable, took the form of quotations from contemporary sources set as far as possible from the paintings on small stands in the centre of each room. To eyes inflamed by visions of marxist infiltration, however, these elegantly designed objects became the 'soap boxes' of a political hack bent on destroying the spectator's pleasure. The quotations, if they were read at all, would simply have reminded visitors inclined to see the pictures as evidence of some lost eighteenth-century Golden Age, that the ideas of rural harmony they seemed to evoke had been myths fostered by a landowning elite seeking to glamorize its exploitation of a socially divided and often cruel society.

What really sparked off the controversy was the lengthy introduction to the catalogue by the Canadian art historian David Solkin which drew out in detail some of the ideological implications of Wilson's enterprise. Catalogues very rarely attract any comment at all from the press, but this closely argued piece of analysis – remarkable for its effective deployment of a wide range of material from contemporary periodicals, poetry and pamphlet literature, and for its departure from the narrowly art-historical and biographical perspective of most such writing – was singled out for attack by critics of various political colourings. That it is the response which is extraordinary, rather than the catalogue itself, is underlined by the straightforwardly favourable mentions that the catalogue got in the *Times* and the *Sunday Times*. These would seem to indicate that there was nothing obvious in Solkin's introduction that need have offended the sensibilities of a 'liberal' critic. While the *Telegraph* inveighed against this 'especially shoddy example of political distortion', the *Sunday Times* critic Marina Vaizey could commend it as '....a lively demonstration of the new wave in art history which emphasizes the social, economic and political milieu. We are persuaded not only to look at the paintings, but to consider them in their role as embodying a complex web of ideas...'

Solkin's approach should not have come as a shock to anyone familiar with recent writing about eighteenth-century British art. Many of the issues he raises have already been treated by the highly prolific Professor Ronald Paulson of Yale University, while John Barrell, in *The Dark Side of the Landscape* (Cambridge 1980), deals extensively with the questions of political ideology that critics of Solkin found so objectionable. In fact the politics of the eighteenth-century English landscape had featured prominently in another exhibition held at the Tate Gallery ten years ago, *Landscape in Britain c. 1750-1850*. There the walls of one whole room had been littered with 'subversive' quotations from such texts as Oliver Goldsmith's *Deserted Village:* 'The man of wealth and pride/ Takes up the space that many poor supplied;/ Space for his lake, his park's extended bounds...' Indeed, this exhibition had been rather more 'radical' in its presentation than the

Wilson show – dealing with landscape art as a broad cultural phenomenon, rather than following the career of a single artist. The essentially monographic nature of Solkin's enterprise forced him into a position where, after trying to situate Wilson's art within a broader historical problematic, he was obliged to turn around and proffer his analysis as part of the celebration of a neglected great artist: 'I hope that we can now pay fuller tribute to the richness and vitality of (Wilson's) artistic achievement', he remarks at the end of his introductory essay.

Neither this, nor the acknowledgements to the influential old-master dealer Agnew's or to the 'Private Collectors' who 'have been wonderfully co-operative', gave pause to the fury of the *Daily Telegraph* editorialist once he suspected that the eighteenth-century English landscape was being desecrated by a rabid foreign marxist. His was the most extraordinary response, perhaps rivalled in its political vitriol only by the vicious editorial commentary in *Apollo*, one of the organs of the art trade. That someone had seen fit to make an art exhibition the occasion for a political editorial seems to have perplexed even the *Telegraph's* own regular arts reviewer, Terence Mullaly. But at stake was an important part of England's national heritage – the gentlemanly ethos of Augustan England, evidently closer to the hearts of the 'cultured' New Right than the Victorian values so admiringly commended by their political allies in recent months:

> The idea of eighteenth-century England as a golden era of liberty and social calm is a notion bequeathed to us by that age itself. It has long been offensive, however, to Marxists. Most people are familiar with the beaverings of Tawney, the Hammonds and Hobsbawm to prove that the Industrial Revolution was an age of squalor for the urban poor; fewer, perhaps, with the work of E.P. Thompson, on the earlier eighteenth century, to show that seething local discontent among the rural poor was repressed only by savage penal legislation. Almost no one, however, will be aware that the Left is now into

eighteenth-century art history... a catalogue amusingly
entitled 'The Landscape of Reaction'.... brands our
greatest Augustan landscapist as a purveyor of 'élite cul-
ture' who presents social inequalities in their most flatter-
ing light... if Wilson is a patrician apologist, then the
whole Arcadian tradition which descends to him from
Giorgione to Claude is tainted too. So also are the pastor-
al poets of 18th century England.

Quite so... Far more was at issue, of course, than the validity of
Solkin's argument. And it was not just the extreme Right who
deemed it unacceptable to suggest that the veneer of order
and contentment generally associated with Georgian England
might conceal a more complex and less palatable underside of
rural deprivation and social conflict. In a discussion on Radio
3's 'Critics' Forum', for example, Solkin was chided for failing
to recognize that the eighteenth-century landlords had pro-
vided the NHS and DHSS of their day. Such mythologization
penetrates quite deeply into popular consciousness – witness
how country houses capitalize on the aura of gracious and
harmonious living associated with the period, even as they try
and convert their Capability Brown gardens into safari parks,
or the way in which, in the antiques and collecting world, the
eighteenth century still has a special status as the embodiment
of a genuine taste and refinement, supposedly lost with the
onslaught of industrialization.

This mythology of the eighteenth century merges imper-
ceptibly into a perhaps even more widespread cult of the En-
glish countryside, which in turn is closely bound up with the
English 'love' of landscape painting. Pictures of the country-
side are supposed to provide pure visual evocations of an ideal
rural experience. To take one typical response to Wilson's
work: 'Wilson asks for, and gets, a most elusive mood, a sense
of loneliness, as if the artist had actually tip-toed away and left
nature alone with her thoughts.' Critics in the *Spectator*, the
New Statesman, the *Guardian*, the *Times Literary Supplement*, in
'Critics' Forum' and on 'Kaleidoscope', all sprung to the de-
fence of a traditional appreciation of landscape art. For them,

the experience of Wilson's landscapes could only properly be defined by such terms as 'admiration', 'sheer sensuous pleasure', 'pleasure and respect', 'quality', 'masterpiece', 'magnificent evocation of superb scenery', 'one of the great masters of the calm, the stillpoint'. At one level, what seemed to be bothering people was the intrusion of a more cognitive approach to viewing art in a domain where previously pure unreflexive pleasure had seemed the norm. There was the consistent refrain that Solkin's historical analysis posed an obstacle between the viewer and the art work, doing violence to what the paintings had to offer. In the words of the *Guardian* critic: 'I don't recall a catalogue which has proved less of a help and more of a hindrance to the enjoyment of an exhibition.' More temperate reactions revealed a similar kind of anxiety – 'I found myself wondering if social comment is altogether to the point with Wilson, a gentle landscape painter.'

It was surprising to discover how many 'liberal' critics still feel the need, in a context such as this, to cling to the idea that art provides a transcendent experience, above politics and ideology; no doubt a very much more politicized approach would be deemed appropriate for an exhibition of Soviet landscape painting. (Claire Tomalin, speaking on 'Critics' Forum', suggested that Solkin's interpretation of Wilson's work was tantamount to reproaching him for not painting collective farms.) If Solkin then was imposing a false political interpretation on Wilson's art, what was its real meaning? What was there to pit against this 'false vision of a rural setting'? After trailing a particularly lyrical evocation of 'cool Italian valleys, lush hillsides pushed apart by lazily winding waterways and dotted with feathery trees and ruined temples', Waldemar Januszczak of the *Guardian* emerged triumphant proclaiming: 'ever since Virgil first dreamed the pastoral dream in his Eclogues it has represented hopes which are limitless rather than limited'. Perhaps he might have been better employed asking why Virgil should have sung the joys of rural labour in the first place.

There were strong elements of professional jealousy in all

of this. The sensitive critic's prerogative to present his or her own personal response as somehow an objectively valid one was seen to be threatened by Solkin's insistence on the importance of historical analysis. One passage on the first page of his introduction caused particular offence: ' The immediate physical presence of these pictures should not lure us into the trap of assuming that they – or indeed any works of art – possess an inherent timeless meaning which is therefore automatically accessible to our comprehension... for us, who possess a profoundly different mentality fashioned by a society so unlike that of eighteenth-century Britain, (their original) meanings have become almost entirely lost. By themselves the images may provide us with varying degrees of pleasure, but their appearance alone teaches us remarkably little.' This is hardly a novel, let alone a very controversial statement; variants of it have been the stock-in-trade of historical research for some time. If anything, Solkin might be accused of safely historicizing the ideological resonances of Wilson's pictures; it is perhaps ironical how clearly the reaction to his arguments highlights the resilience of much of the social mythology he so emphatically consigns to the historical past.

Does the whole furore provide further proof of the peculiar, one might almost say eccentric, conservatism of present-day British culture? This certainly was the conclusion arrived at by the critic of a rather glossy German magazine of travel and culture, *Westermanns Monatshefte*: 'Is conservatism then so deep-rooted amongst the English that they resist anything that smacks of a new point of view? Has patriotic zeal been aroused because an American has taken possession of an English painter? Or is English landscape painting so much part of English mythology, that people were provoked to fury by Solkin's materialistic notion that understanding can only begin where mythology ends?' No doubt from such a continental perspective, the whole political controversy over Colin MacCabe's Cambridge (non)appointment would have appeared equally mad, as too did the patriotic fervour stirred by the Falklands War....

In all of this fuss, one rather important point appears to

have been forgotten – Solkin's catalogue actually succeeded in making Wilson's work, previously of interest mainly to specialist connoisseurs, into a cultural phenomenon attracting widespread interest and debate. This he did by setting to one side the well-worn art-historical discussions about the balance between naturalism and classicism in Wilson's landscapes, and raising much more fundamental questions about why the artistically ambitious view of rural concord typified by his work took hold at this particular point in British history. For it was not only Wilson, but also such contemporaries as Gainsborough, who in the mid-eighteenth century started producing a naturalized landscape that was no longer strictly topographical but aspired to the status of old master painting. Nor was Wilson alone in dwelling on happy rurals lounging around at sunset in perfect harmony with their surroundings. In other words, Solkin has asked about the meanings of eighteenth-century British landscape in terms that have significance outside the art-historical profession, and in ways that are no longer bound up with the talk of connoisseurs and owners of eighteenth-century painting.

Of course, Wilson's landscapes were not a programmatic articulation of the political ideology of the landed upper classes of eighteenth-century Britain. There were, after all, several such ideologies, and these were defined, their political contradictions explicitly dealt with and defused, not through pictures, but through the written word in the articles and political tracts which Solkin quotes to such good effect; and it was in the literature of the period that these ideologies were more consciously played off against traditional constructions of a perfect and harmonious society. In a world where high art was so completely dominated by the values and interests of the landowning elite, and in the absence of any other source of financial support for artists with pretensions to professional success, there was no real alternative for them but to operate within this way of seeing the world. As Solkin writes, 'No doubt Wilson himself was largely, if not totally unaware of the myths which his pictures conveyed, and of the social attitudes they expressed.... Wilson himself was primarily concerned

with achieving professional dignity and security; he simply had a job to do, and his performance was one of undeniable skill. But all these various factors do not make the products of his brush one whit more objective, more neutral.' In other words, the 'interest' Wilson was directly pursuing was professional success, and this necessarily entailed working in harmony with, indeed inventing, new more resonant and vivid pictorial evocations of his patrons' ideologies.

Solkin's ideological reading of Wilson's work, then, need not in any way be contradicted by what we know of the artist's less than harmonious life. He died in straitened circumstances after enjoying an initial period of success, apparently an alcoholic. Contemporaries described him as an independent and abrasive character who, while he painted pictures that were widely admired and was very ambitious, ran into financial difficulties because he failed to cultivate social relations with his patrons: 'Wilson... was conscious of his merits, and not of the most bending disposition... It may be questioned whether he did not become martyr to a principle of disdaining to humble himself to those, however superior to himself in rank or riches, who measure by inches and value by pounds.' After his death, when English artists were beginning openly to defend their professional interests against the gentleman-connoisseurs, Wilson came to be viewed as one of several unrecognized British geniuses who had suffered in the cause of high art. The painter Fuseli wrote of him in 1805: 'Wilson is now numbered among the classics of art, though little more than the fifth part of a century has elapsed since death relieved him of the apathy of Cognoscenti, the envy of rivals, and the neglect of a tasteless public.'

Solkin however failed to exploit the apparent contradictions within Wilson's enterprise and sometimes made it appear as if individual pictures were programmatic statements of a uniform 'patrician' ideology. On occasions, for instance, he would seem to suggest that Wilson's pictures were openly asserting the landowner's view of the world, actively resolving its contradictions, without reference to who might be looking at them. The pictures were designed to provide

patrons with an occasion for conjuring up a world entirely in harmony with their own interests, one where any potential conflicts were excluded, or displaced from the realm of the social and political, and only reactivated in forms that could be contained comfortably within the aesthetic domain. However, there is the implication, for example in Solkin's discussion of a particularly popular Wilson picture, the *White Monk*, that the aesthetic resolution of two seemingly discordant pictorial modes – a sublime landscape with hermits on the left set off against a beautiful landscape with lovers on the right – would have conveyed to contemporaries the political idea of *concordia discors* (the idea that society's overall harmony was the result of a providentially ordered combination of seemingly antagonistic interests and callings). Yet the pictorial construction would at best have served only as a general metaphor of order within difference; without a more specifically political context to secure the association, it is hard to see how pictorial structures would have conjured up ideas of political order. Solkin's occasional tendency to art-historical over-interpretation is accompanied by odd lapses into a mechanistic view of history: 'Art was produced for and judged upon the basis of its social utility – or, more specifically in the case of Wilson and his public, on how it furthered the interest of Britain's patrician élite.' Such passages unfortunately proved grist to the mill for those who wished to caricature Solkin's arguments. Graham Reynolds in the *TLS* was only too typical when he complained how Wilson had been represented as someone who 'painted landscapes not because he enjoyed Nature, or because some of his patrons liked his work, but because he was impelled to justify the possessions of the rich and to keep the poor in their place.' But it would not have helped if Solkin had been more consistently sophisticated in his analysis. It is hardly in the interests of the anti-marxist even to consider how dominant ideologies might permeate the sacred precincts of art. Take the editorial comment in the *Telegraph*: 'Even the wretched Solkin rubbishes his own theory by allowing that Wilson did not "consciously" depict the patrician life'. Pride of place in all this controversy, however, ought to be

given to Denys Sutton's editorial in *Apollo*, the colourful art magazine that advertises itself as 'read, re-read and treasured' by 'collectors and cognoscenti'. Sutton gave vent to an anti-marxist paranoia which, if it did not so closely echo the spate of patriotic attacks on Blunt's so-called 'treachery', might well be enjoyed as a spoof on the lunatic right. No doubt he was offended by the fact that he, a supporter of the system, had to make a living as a small-scale entrepreneur while respectable institutions subsidised the work of enemies of the state. His resentment focused on the fact that this 'sloppy publication' should have been produced under the auspices of Britoil, the sponsors of the exhibition, and with the blessing of Alan Bowness, the 'amiable if indulgent' director of the Tate (who in fact in the Foreword to the catalogue was careful to disassociate himself from Solkin's interpretation of Wilson). Having paid off his professional scores, Sutton then adopted a more sinister tone. When, in future, museum directors fail to impose effective censorship, others will have to step in and do it for them: 'If some measure of self-policing (or self-discipline) is not instituted their ostensible masters may be obliged to take a more active role in the management of those institutions which, nominally at any rate, are in their charge.'

Spelling out the rationale behind this display of gentlemanly intimidation, Sutton went on: 'Inevitably one consequence of the Marxist approach to historical writing is that it conditions the minds of some of its readers into accepting the policies of the Soviet régime. Now Mr. Andropov is Secretary-General of the Communist Party, infiltration will assume a more subtle and insidious form and an increasingly determined effort will be made to court the intellectuals, often only too prone to flattery.' Such dark talk about 'Marxist infiltration into art publications', no doubt partly prompted by memories of the Blunt affair, concluded with a Churchillian flourish: 'the price of freedom is eternal vigilance'. The extremity of Sutton's response may seem a little comic in this context, but he is not the only one spoiling for a return to the politics of the Cold War. Let's hope he's not applying for a job at a national museum...

Feminism, Art History and Cultural Politics

Lynda Nead

The definition of feminism as an 'approach' to art history acts as a sharp reminder of the potency and flexibility of the traditional academic discipline. The idea that feminism can be offered as one possibility within a range of new, alternative art historical methods highlights the difficulties and dangers involved in formulating an effective agenda for feminist cultural politics today.

The classification of feminism as a new approach to art history has significant effects and worrying implications. The process works to dismantle feminism as a set of political beliefs and to reformulate it as a fashionable 'style' within the institutions of academia. As academic novelty, feminism occupies a marginal position. The identification of diverse marginal practices is important in the definition of a dominant practice. Whilst it is true that new approaches may highlight the weaknesses and eventually subvert the ideas and values which are propagated within the dominant model, we should also be aware that the existence of marginal positions is essential in the perpetuation of the dominant form. Meaning is produced in terms of difference and feminism has to resist simply becoming a term of difference for the traditional discipline. By

including terms such as 'Marxism... Structuralism... Feminism' on its courses and bibliographies, art history can appear open, inquiring and progressive. However, it is significant that conventional art history never declares or articulates its own position – 'positions' and 'interests' are relegated to the approaches courses. These courses have been introduced into the discipline over the last five to ten years. Running in conjunction with the traditional academic courses, they occupy a range of positions within different institutions. The content of the courses is equally diverse: from the historiography of art to more radical questioning of method and cultural production. What is most astonishing is the extent to which the academic courses have, on the whole, remained impervious to the issues raised within approaches courses.

The new approaches are constituted as temporary and ephemeral in contrast to the permanence and continuity of the traditional practices. They are contingent and fleeting in opposition to the timeless and universal principles which, so the argument goes, are at the base of art history. Feminism cannot be reduced to demonstrating the liberalism of art history. The relationship of feminism to art history cannot be one of exciting new stimulus to the old discipline. The terms of the relationship have to be redefined. Feminism is not and should never be an approach to art history. Rather, feminism has identified art history as a form of patriarchal culture, and has begun to challenge the values and ideas constructed within art history as part of its programme of cultural politics. In 1985, in a period of severe cuts in education and frightening levels of unemployment, feminists have to reconsider sexual politics and cultural politics as they intersect within art history. This may seem a rather subdued note on which to begin an essay on feminist politics and art history but it does allow for progress and development.

In order to understand the current relationship between feminism and art history, it is useful to briefly examine its development over the last few years. Of course, no single essay could represent the various feminist positions on art and culture. Feminism is not a monolithic political ideology. The

women's movement is composed of a diverse range of beliefs and practices and it would be more accurate to refer to feminisms than feminism. Women who are involved in the movement have always acknowledged these different positions but within art history the complexity of feminism is denied. Art history cannot accommodate the notion of feminism as a complex set of political ideologies; it therefore redefines feminism as a unified position which can be adopted by art historians in an unproblematic manner.

From the late 1970s, a number of institutions introduced approaches courses to their art history syllabuses. Of course the interests involved were not always the same; nevertheless, in 1985, it is now regarded as quite usual and desirable for departments to offer special 'theory' courses. In many ways, these courses have become the dumping-ground for the radical theories that were beginning to infiltrate the hallowed realm of the academic discipline. 'Feminism' was comfortably accommodated. Allocated a slot in the approaches courses, feminism was categorized and contained as a marginal position outside the main body of art historical work and research. The implications of feminism were regulated, and the art historical litany could be maintained as an uncontaminated, neutral territory, free from the bias of a particular approach and outside the domain of politics. By locating the political exclusively within approaches courses, the academic discipline could be represented as impartial, objective and factual.

Approaches courses are taught alongside conventional academic courses. These courses are organized around particular objects and named individuals and perpetuate the concepts of great art and great artists. In its persistent celebration of great art and artists, art history plays an important role in the production of cultural values within society. It is taken for granted that certain objects and individuals are implicitly worth studying, and that both express the special significance and values of high culture. Conventional art history, then, rests on the dual constructs of 'masterpieces' and 'great artists' and it is here that feminist interventions can be most critical.

Feminist involvement with art history may be divided into

two stages. In the following brief account of these stages individual authors and works will not be cited. There have been a number of significant publications on the history of art from within the women's movement; to refer to only a few would be to privilege this material at the expense of the rest. It would eclipse the work at research level which has been carried out in the past and which continues to make an important contribution today. The first stage was characterized by the attempt to rediscover the names and work of women artists and to integrate them into the traditional discipline. It was an additive process and did not seek to challenge the categories and values of art history. Working within the terms of the conventional discipline, this work produced a substantial body of published material and was a crucial stage in the formation of feminist cultural politics.

The second and present stage may be defined in terms of a far more critical approach to the discipline itself. Rather than integration, feminists have begun to confront the values and interests that are produced within art history and to expose the function of culture in the formation of patriarchy. In many ways, this shift is part of the changes and developments within the women's movement as a whole. Some of the optimism of the 1970s may have disappeared in the 1980s but there is now a more rigorous attention to the arena of cultural politics and a greater refusal to take on board the values and interests of patriarchal culture. It is a complicated but exciting moment to be involved in feminist and cultural politics, although this activity is constantly set against the debilitating effects of education cuts and unemployment.

Feminism has traditionally been associated with and confined to work on either women artists or representations of woman. The politics of feminism have thus been categorized in terms of 'women's issues'. At one level, this has resulted in a form of essentialism. For example, debates around the question of a feminine aesthetic (an issue which is discussed in all areas of women's studies) tend to imply that art produced by women expresses a common, universal female nature or spirit. Women's art is thus constituted as a unified category dis-

tinct and different to art produced by men. This practice fails to address the inter-relationship of class and gender and subordinates historical change to the idea of a timeless body of work unified by the sex of its creators. Feminist work on culture need not adopt an essentialist position. Indeed, work from within the women's movement has already begun to address the historical conditions of art production and the various ways in which women have been positioned in relation to patriarchal culture.

Continuing from these developments it is possible to set out an agenda for feminist cultural politics. An adequate feminist practice would pose new questions concerning the role of culture in the construction of patriarchy. It should address the various definitions of class, gender, morality, culture etc. at any given historical moment. Definitions of gender cannot be examined in isolation from other forms of power relations such as race and class – all are part of the construction of social, political and economic power. Feminism should analyse the function of visual representations and the work they do. It should expose the relationships between meanings which are produced at the level of culture and meanings which are produced at other levels of the social formation. Clearly, this practice moves away from the structures and procedures of conventional art history. Feminism redefines the objects and aims of study. It breaks out of a marginal position within approaches courses and challenges and reworks the discipline itself.

So perhaps it is time to rethink the relations of power which are constituted in the now familiar phrase 'feminism and art history'. This phrase suggests either that feminism has taken on the barely altered cultural values of art history, or that feminism has been recouped and placed under the umbrella of the traditional discipline. Either sense is unsatisfactory and fails to address the potentially radical nature of feminist cultural politics. Feminism must resist the role of revamping the dominant institutional practices. Its importance lies in its project to demonstrate the work of visual representation and the social function of culture and cultural values.

Pater, Stokes and Art History:
The Aesthetic Sensibility

Michael O'Pray

A true criticism of philosophic doctrine, as of every pro-
duct of human mind, must begin with an historic estimate
of the conditions, antecedent and contemporary, which
helped to make it precisely what it was. But a complete
criticism does not end there. In the evolution of abstract
doctrine as we find it written in the history of philosophy,
if there is always, on one side, the fatal, irresistible, mecha-
nic play of circumstances – the circumstances of a particu-
lar age, which may be analysed and explained; there is
always also, as if acting from the opposite side, the compa-
ratively inexplicable force of personality, resistant to,
while it is moulded by, them.

Walter Pater, *Plato and Platonism*

Though Pater is remembered as an aesthete at the latter end
of nineteenth-century Romanticism and as the philosopher of
the English Decadents, the above passage is a reminder that
his critical practice in painting and literature was the work of a
writer well aware of the importance and the difficulty of his-
torical explanation where it concerned the 'product of human
mind'. The fundamental problem for any history of inten-

tionally constructed objects where beliefs, desires, feelings
and phantasies are brought to bear on the process of produc-
ing the object, is one of doing justice to the complexity of
determination of the object, in this case an art object, so that
not only the broad social and economic conditions are disco-
vered but also the formative influence of the artist's personal-
ity, taken in its broadest sense, is accounted for too. Pater's
succinct statement of this problem dispels the view that he was
someone blinded by abject subjectivism and trapped by a style
which even when he was alive led to 'neglect, indifference,
misunderstanding and near-ridicule'. Many writers have
traced Pater's influence and have argued for his importance
and relevance, particularly in the area of poetry – including
T.S. Eliot, Graham Hough, Frank Kermode, Ian Fletcher,
Richard Wollheim, Harold Bloom and Kenneth Clark.[1] On
the surface it might seem perverse to introduce Walter Pater
into any examination of the 'new' art historians with their
emphasis on methodology and a virulent anti-subjectivist
stance, for it would seem as if his work represents the very
tradition they would like to extinguish. But in fact Pater's
belief that the artist's personality played as important a part as
history in the creation of an art object can serve as an antidote
to the new art historian's reliance on social and historical ex-
planation alone. I want to argue that in Pater, and later in
Adrian Stokes, one finds writing about art and the history of
art that engages with the essential features of art, features
flowing from what Pater calls the 'personality', and what we
might call the psychological aspects of art.

A central tenet of recent art history is an antagonism to-
wards subjectivity where that involves any talk of 'genius',
'artistic expression' or 'aesthetic response'. In itself this is
hardly new; Frederick Antal in his seminal essay of 1949,
'Remarks on the Method of Art-History', argued for a break
with traditional art history's indifference to the social deter-
mination of art. He seemed to have Pater in mind when he
speaks of the 'impressionistic form' of art criticism of the late
nineteenth century which was 'largely concerned to describe
the fleeting reactions of a sensitive beholder before a work of

art'. The new stress on the social and economic conditions in which art was created and consumed was an obvious advance but it had its casualties: its silence on the role played by the artist as a personality and its discomfort in dealing with aesthetic response.

Pater is doubly useful for us here, for his view of the artist's personality is strongly connected to the whole area of aesthetic understanding and evaluation. In Pater's view, any judgment of a work of art must entail a response by the viewer, and this means invoking some notion of artistic expression, however minimal. It is quite clear that for both Pater and Stokes the art object 'is a form of externalization, of making concrete the inner world'.[2] And it is implicit that the externalization is based on a common psychological structure and content, so that both artist and spectator are seen as sharing the projections of beliefs, desires, feelings and phantasies on to any work of art. For Stokes in particular, as Wollheim points out, 'the artist can also become in the fullest sense the spectator of his own work: not just of the finished work, but of the work in all its stages of progress'.[3] So the stress laid upon the spectator by Pater – 'the sensitive beholder' – is not necessarily an imposition of the spectator as sole determinant of the art object, for his insights do not necessarily mean they are inapplicable to the artist, although it is in the later thinker, Adrian Stokes, that this issue is an explicit one. Hence the stress on 'personality' here is to understand Pater's concerns as ones that are central to a number of key issues connected with aesthetics.

On this issue it is perhaps illuminating to isolate some remarks in Janet Wolff's book *The Social Production of Art*. She begins the book with the true, if one-sided, sentence 'Art is a social product', and ends it by admitting that she has 'not attempted to address... the question of the nature of the aesthetic experience... (or) the question of the basis of aesthetic judgment and evaluation'. Her awareness and sensitivity to the problem of reductionism is a singular merit of her book, but it is no accident that her overall sympathies in art history for the social determination model should leave no space for these issues which have proved so insurmountable to any

genuine methodology of social art history. The fact that Wolff places the emphasis on the spectator, and rightly so, is symptomatic of the antagonism towards the role of the artist felt by her and others who embrace the social art history view. What is missing from the account, broadly speaking, is any psychological aspect.

A major problem with the new art historians is their insistence on the spectator's engagement with the art object being of an intellectual kind. It is the meanings in the painting, poem or sculpture which are important. These meanings are constructed by historical conditions and by the spectator, the personality of the artist being by-passed. Locating and deciphering the meanings in a work of art leaves the affective aspects of the work untouched, so that feelings, moods and aesthetic experience are left stranded or denied altogether as somehow ideologically suspect or subjectivist.

The omission of these aspects fails to make a distinction between an art object and any other cultural object. It preserves nothing of the art object which makes it essentially that kind of object and not some other. In a remarkable way it leaves unaddressed the problem of Duchamp's ready-mades, probably one of the central problems of any philosophy of art in this century. In other words, what is the nature of the art object? Part of the response to this question on the part of the new art historians is to sustain the traditional dualism of the mind between the intellect and the passions. As such it is reminiscent of the philosophical doctrines of the seventeenth-century philosophers like Descartes, Spinoza, Hume and Hobbes who tended towards a view of the rational understanding in struggle with the primitive passions. Mastery of the latter by the former was an imperative for civilisation, a view implicit in one form in Freud's own writing, and perhaps it is interesting to note that Freud's own relationship to art was very much an intellectual one – the rational solution of a visual puzzle in the case of painting and sculpture.[4]

Harold Bloom points out that Pater represents a sensibility common in the nineteenth-century critics Coleridge, Lamb, Hazlitt, De Quincey and Ruskin. In their writings there is no

clear-cut distinction between the historical recovery of an artist, art movement or epoch and aesthetic judgment itself; on the contrary, they are indissolubly mixed. For this reason, Pater has much to say to the twentieth century. David Sylvester's remark about Adrian Stokes – 'the texture of his writing is analagous to the texture of our actual experience of art'[5] – is equally applicable to Pater. But more than a refined sensibility, Pater presents a subtle picture of an array of issues relevant to present-day debates. It is not simply the area of effects, the sensations felt by a sensitive viewer, that is central to his writings but also what Richard Wollheim describes as 'the expressive qualities of works of art and the temperaments or types of mind that found expression in these qualities'. Pater can create pictures of creators. In *Imaginary Portraits* and *Appreciations* he deals with temperament and sensibility, and in *Marius the Epicurean* he forges a figure through whom the ideas and feelings of an epoch are personified. Where Pater's critical writings treat of historical figures and moments he resists the analytical approach, presenting instead an intricate texture of aesthetic feelings, interpretation and philosophy of art.

Pater views art and its history from the 'inside' so to speak. He takes a viewpoint from which he projects sensations, perceptions and ideas gathered from the material at hand – writings, paintings, historical data – and from which a sensibility can be constructed. This leap of the imagination particularly into the past does not stem from any indifference to social and historical conditions but from a regard and respect for the involvement of personality (the artist's and the viewer's) in any work of art. This approach flies in the face of the new art history which cherishes the view from the 'outside' – meanings being ascribed to a work of art through analyzing its historical conditions of existence in class and ideology.

The reveries, epiphanies and privileged moments found in Pater's work find their finest expression and their foundation in his strange autobiographical essay *The Child in the House*:

The realities and passions, the rumours of the greater world without, steal in upon us, each by its own special little passageway, through the wall of custom about us; and never afterwards quite detach themselves from this or that accident, or trick, in the mode of their first entrance to us. Our susceptibilities, the discovery of our powers, manifold experiences – our various experiences of the coming and going of bodily pain, for instance – belong to this or the other well-remembered place in the material habitation – that little white room with the window across which the heavy blossoms could beat so peevishly in the wind, with just that particular catch or throb, such a sense of teasing in it, on gusty mornings; and the early habitation thus gradually becomes a sort of material shrine or sanctuary of sentiment; a system of visible symbolism interweaves itself through all our thoughts and passions; and irresistibly, little shapes, voices, accidents – the angle at which the sun in the morning fell on the pillow – become parts of the great chain wherein we are bound.

This passage is an innocent and haunting precursor to the psychoanalytical idea of incorporation by which phantasy is founded. What Pater calls 'visible symbolism' in this passage suggests a notion of phantasy in which the originating experience comes to form and colour future ones – both in a structural sense and an emotional one too. Later in the same essay, Pater connects the early experience of the blossom of the red hawthorn with a dream and subsequently with 'the goodly crimson' found in the paintings of old Venetian masters and old Flemish tapestries. This 'brainbuilding', as he called it, through such experiences, is most brilliantly developed both as art criticism and psychological theory in the writings of the critic, painter and poet, Adrian Stokes,[6] who is most directly related to Pater in style and sensibility, and perhaps philosophical inclination. If in later Stokes, the language is different due to his immersion in psychoanalysis (he was analysed by Melanie Klein in the 1930s) there is nonetheless a similar response to art, whereby the connections and associations made before a painting or building are diverse, oblique and

often mingled with the primitive. For Stokes, and implicitly for Pater also we feel, the production and reception of art was always a matter of projections and introjections.

Any brief review of Pater's work, and particularly in the context of discussing art history, must mention his own notion of history, one ensuing from his studies of Hegel and Darwin. Pater understood history as a continual dialectic between two opposing tendencies: the centripetal and the centrifugal. The centripetal is to be identified with the Classic tendency – an ordering and restrained attitude – and the centrifugal with Romanticism – 'flying from the centre... throwing itself forth in endless play of undirected imagination; delighting in brightness and colour, in beautiful material, in changeful form everywhere, in poetry, in philosophy...'.[7] Sergei Eisenstein in his later aesthetics in *The Film Sense* when discussing the 'synchronisation of the senses' also divided cultural movements with the same categories. For Eisenstein, the centrifugal was identified with periods of decadence when there is 'hurling apart of all unifying tendencies'. Later Stokes was to use a vocabulary and conceptual system which understood these conflicting tendencies of fragmentation and wholeness in psychoanalytical terms. It should not be implied by this that historical analysis should be replaced by these systems, although Harold Bloom writing in 1974 wonders whether 'modern criticism as yet has caught up with Pater'.

For Pater, Stokes and for that matter Eisenstein, the question is one of attitudes of mind, or what might these days be called ideology. In other words, art is a practice involving the making of objects (be they paintings, books or music) grounded in the mind. The aesthetic pleasure possible before Agostino di Duccio's *Madonna and Child with Angels* must be in part at very least a gathering up through one's own desires, beliefs and feelings with those of the artist. It is this capturing of the artist's phantasies by the spectator which distinguishes the pleasure before natural phenomena from that induced by art objects. For Pater, this sensitivity to the object, by both artists and spectators, is not something to be taken for granted as a given. On the contrary, it can be lost, corrupted and

forgotten. The stress by the new art historians on the abstract systems that supposedly produce art, seems to imply that the production and appreciation of art is at the mercy of 'history'. The philistinism inherent in such a position seems hardly progressive. Art history without aesthetics seems as blind as aesthetics without history would be empty.

Notes

1 T.S. Eliot, 'The Place of Pater', in *The Eighteen-Eighties*, Walter de la Mare, ed., Cambridge 1930; Graham Hough, *The Last Romantics*, London 1949; Frank Kermode, *Romantic Image*, London 1957; Ian Fletcher, *Walter Pater*, revised edn, Harlow 1971; Richard Wollheim, 'The Artistic Temperament', *The Times Literary Supplement*, no. 3,990, 22 September 1978, pp. 105-6; Harold Bloom, 'Introduction: The Crystal Man', in *Selected Writings of Walter Pater*, Harold Bloom ed., London 1974; Kenneth Clark, *Moments of Vision*, London 1981, pp. 130-142.

2 Richard Wollheim, 'Introduction', in *The Image in Form: Selected Writings of Adrian Stokes*, Richard Wollheim ed., Harmondsworth 1972.

3 Ibid

4 For example, Sigmund Freud, *Leonardo da Vinci and a Memory of his Childhood*, Harmondsworth 1963.

5 David Sylvester, 'All at Once', *The New Statesman*, vol. LXII, no. 1587, 11 August 1961, p. 190.

6 See *The Critical Writings of Adrian Stokes*, Lawrence Gowing, ed., vols. I - III, London 1978.

7 Walter Pater, *Greek Studies: A Series of Lectures*, London 1895, quoted in Bloom, *Selected Writings of Walter Pater*, p. xxx.

I would like to thank Jill McGreal for her criticism of an earlier draft.

The New Art History and Art Criticism

Paul Overy

In an article in the *Times Literary Supplement* published in 1974, T.J. Clark made a plea for a renewal of art history.[1] He called for a return of the subject to the intellectual rigour and commitment of its founders in the German-speaking world during the nineteenth and early twentieth centuries;[2] but an art history which would be materialist rather than idealist, its practice less isolated from history, economics, politics and social life. Anywhere other than the *TLS*, Clark might have described what he wanted as a 'historical materialist' history of art. But there, and in the introduction to *Image of the People*, published the previous year, he referred to this as a 'social history of art', and added a number of riders as to what a social history of art might *not* be.[3]

Curiously, Clark did not refer to an intermediate generation of art historians who wrote just that, and whose names were, for a long time, 'written out of history' – to use a phrase frequently employed by 'new art historians'[4] – the generation of Antal, Hauser and Klingender, who used historical materialism as their conceptual tool. To understand why it should have been necessary in the early 1970s for Clark (and others) to call for a new kind of art history we will need briefly to

examine the facts of British cultural life in the decades since the second world war and the particular way in which art history was affected by the Cold War.

This was not quite the McCarthyite purge which castrated a whole generation of intellectuals in the USA, but a typically British adaptation, muffled and unspoken. Nevertheless it infected all aspects of cultural life. Marxist academics, writers and journalists were vigorously discriminated against in getting jobs or obtaining commissions. Many found it necessary to play down or try to forget their own past links with the left. Editors of magazines were absurdly cautious, indulging in self-censorship to forestall the disapproval of management. They would, for example, change the word 'bourgeois' in a writer's copy, substituting the – they imagined – more innocuous, or at least less loaded, word 'middle-class'.

This lasted until the early seventies. As late as 1968 Arthur Elton could publish a substantially rewritten version of Francis Klingender's pioneering study, *Art and the Industrial Revolution*, introducing new material from his own collection of topographical prints and blunting the marxist thrust of Klingender's original argument, sometimes completely changing the meaning. The result was a bastardized book which bears little resemblance to Klingender's original project.[5] Elton's doctored and debilitated version is still in print in a popular paperback edition which appears on the reading lists of innumerable British educational institutions.[6]

After 1968 that probably would not have happened. For 1968 revealed that marxism was no political threat at all in Britain and could henceforth be allowed its run in British academic life and even in Grub Street. Here, 1968 toppled no de Gaulle. In England the left, in Benjamin's words about Marinetti, 'aestheticized politics'. In England 1968 was largely confined to Hornsey College of Art which shortly after was absorbed into Middlesex Polytechnic and spawned the magazine *Block* where much of the 'new art history' was to appear.

Art history – a relatively new academic subject in Britain compared to German-speaking countries – was dominated in the years after the second world war by the Courtauld Insti-

tute of Art. Until the 1960s this was virtually the only institu-
tion where the subject was taught. The director of the insti-
tute, initially founded and funded by the eponymous textile
multinational, was Anthony Blunt, a long-standing Soviet spy.
To provide a convincing cover for his later activities – for
Blunt had been openly a Communist in the thirties – the Cour-
tauld was devoted to a conception of art history which was
formalist and 'value-free'. Blunt became Keeper of the
Queen's Pictures and obtained a knighthood.

In a well-known essay 'Components of the National Cul-
ture', Perry Anderson has pointed out the dominance of Brit-
ish post-war culture by a generation of continental refugees
from fascism who – unlike those who went elsewhere (or killed
themselves like Walter Benjamin) – formed a 'white' or essen-
tially reactionary and anti-marxist force. In the late 1960s
Anderson wrote: 'Establishment British culture rewarded
them amply for their services, with the appropriate
apotheosis: Sir Lewis Namier, Sir Karl Popper, Sir Isaiah Ber-
lin and (perhaps soon) Sir Ernst Gombrich.'[7] Gombrich duly
got his knighthood, although Blunt lost his. These two, Com-
munist spy and anti-Communist refugee, represented the
dominant and excluding forces in post-war Britain art history.
(Gombrich became the director of the research-based War-
burg Institute while Blunt's Courtauld was largely teaching-
based.) The memory and example of those earlier, radical
social historians of art like Antal and Klingender were kept
alive through the fifties and early sixties not through the work
of art historians but through the practice of the critic John
Berger.

At this period art historians held themselves aloof from the
practice of art criticism which was generally dismissed as 'mere
reviewing'. Blunt, of course, had produced committed left-
wing criticism for the *Spectator* in the late thirties, but anything
like this was carefully avoided in the Cold War climate of the
fifties and early sixties. Yet it was largely through the better
newspaper and periodical criticism from the mid-sixties that
the relevance of art to social life was insisted on in the face of
the indifference and aesthetic isolationism of the art historical

establishment.[8]

Later, in the early seventies, the teaching of fine art practice in polytechnics and a few universities was to have its effect in melding what has come to be called the new art history: for its centres of emergence have been what were the history of art departments of art schools (like Middlesex) or of universities where there were strong links with nearby practical courses (like Leeds). *Art-Language* was a group of practitioners who turned to theory although joined by an art historian, Charles Harrison, who however declared that by so doing he had now become an artist. A number of younger art historians were originally trained in art schools as practitioners.[9]

New art historians have shown themselves more willing to move into an area of critical activity. Yet the new art historians' conception of criticism is a curious one, and there seems to be a strange symbiosis between the new art history and the most formalist of modern critics, Clement Greenberg. Otherwise their attitude towards criticism is not very different from that of more conventional art historians. In 1978 *Art-Language* published a belated, spiteful and inappropriate attack on John Berger's *Ways of Seeing*,[10] a brilliant piece of populist television that changed a whole generation's approach to art.[11]

The new social history of art differs from that of Antal, Hauser or Klingender in that it has absorbed, or at least taken note of, structuralism and semiotics at a theoretical level, and of feminism at a pragmatic level. Thus the new art history is more sophisticated methodologically than that of the 1930s and 1940s which is not, of course, to say that it is better. (Most of its theoretical baggage has, in fact, been taken on board from recent developments in film and literature studies.) Feminist art historians have written back names which should never have dropped out and revealed much about the patriarchal dominance of the visual arts, although – as far as I am aware – have not yet adequately accounted for why this dominance should have been so much greater in visual art than in literature.[12].

If the new art history had tried to avoid the method of conventional art history, its subject matter however has been

much the same. Most of the battles fought so far have been over the traditional terrain of the painting of the second half of the nineteenth century in France. The new art historians might reply – the better to attack old art history which has established its camp firmly on that site. Yet it remains odd that within the 'modernist' arena, so little attention has been focused on Italian Futurism, German Expressionism or Russian Constructivism. If the new art historian has had another field of view then it has almost invariably been that of post-war American abstract painting. And it is surely no coincidence that Clark is now professor of art history at Harvard University. For the French nineteenth century has for long been largely the preserve of American art historians in some of whose work lie the origins of that 'social history of art' to which Clark and others have laid claim.[13]

Although we find in the work of Clark himself a very full (but not always entirely focused) use of thoroughly researched documentary evidence, when it comes to the business of critical discrimination – in terms of what artists are, or are not, discussed at length – the judgements are curiously conventional and unchallenging. For example, in Clark's most recent book *The Painting of Modern Life*,[14] attention is devoted to exactly the same artists as in every other book about later nineteenth-century French painting: Manet, the Impressionists, Seurat, Degas – almost a Leavisite 'great tradition'. There is, for instance, very little about Gustave Caillebotte, a key figure who was both an important painter and the patron of the Impressionists, and thus in the jargon of the new art history, both consumer and producer of art – an undervalued artist whose own work is precisely located in that nexus of leisure, class and control that obsesses Clark and which he insists is the key to the understanding of the whole development of modernism. Perhaps the real answer why Caillebotte is largely written out of the new, as of the old art history, is that his work doesn't fit very neatly with Clark's viewpoint. For Caillebotte is more a realist than a modernist. Yet his painterly (and class) concerns are closer to those of Manet and Degas, who still hog the attention in the new art history even though it

has declared itself against the heroizing and mystification of artists.[15] Caillebotte may well be a lesser artist than Degas.[16] But the discussion of his work is essential to any radical 'social history of art' of the French 1870s and 1880s, not only because of his dual role of painter and patron, but because his best work was so directly related to the modernization of Paris and because among the Impressionists he (ironically the wealthiest) was the only one to produce major paintings whose subject matter was urban workers working.[17]

If in its sallies over well-trodden terrain the new art history seems often oddly deficient as 'critical history' it also has shortcomings as 'social history', however thoroughly new art historians may have dug around in police files in the Archives Nationales in Paris and old guide books to Brittany in the British Library.[18] The main problem is that of class. Painting may be the 'signifying practice' of the bourgeoisie. But which bourgeoisie? Clark believes that representations of class are the most important aspect of late nineteenth-century French painting.[19] But he fails to make any sufficient distinction between the class background of the Impressionists, who were all from the *petite bourgeoisie,* and Manet and Degas who came from *grand bourgeois* backgrounds and had private means. In an article published in 1981, Michael Baldwin, Charles Harrison and Mel Ramsden offered a 'tentative suggestion for a research project in social history' which I take to be something close to what I have argued for here. [20] Such a project in social history, or even 'the social history of art', would be an invaluable contribution to our understanding of the origins of modernism. Rumours during its long parturition suggested that Clark was going to do this in *The Painting of Modern Life.* In practice the book is a cop-out, 'problematizing' a host of lesser issues and hedging itself round with convoluted argument (much of it with the author's own earlier positions) and a self-indulgent approach to research material.[21]

If some new art historians have shown themselves eager to involve themselves in the practice of art criticism, others have undertaken the writing of popular monographs. Griselda Pollock, for example, writes for highly specialized audiences in

magazines like *Screen, Block* and *Art History,* but she has also published popular introductions aimed at the 'hundred-great-pictures' type of audience as well as writing specifically feminist polemics. While in many ways this range and ambition to address different audiences – or willingness to indulge in 'different discursive practices' – is admirable it can produce problems. For instance, in her book on Mary Cassatt, Pollock refers to John Rewald's 'authoritative *The History of Impressionism*',[22] while in an article in *Art History,* jointly written with the ubiquitous Fred Orton, published the same year (1980) we are told: 'Rewald's *The History of Impressionism* (New York 1946) and *Post Impressionism* must be recognised for what they are, symptoms of, and contributions to, the construction of a history of art from the mid-nineteenth century to the present which was conceived by the Cold War warrior and ideologue Alfred H. Barr Jr., Director of the Museum of Modern Art.'[23] Now, Pollock might argue that that is what 'authoritative' *really* means in the 'discourse' of conventional art history. But the problem is that when used in the discourse of a popular monograph the audience is likely to take it for an unambiguously respectful comment, even though Pollock does go on to chide Rewald for his lack of attention to Cassatt's work.

This may not be all that important. Any historian or critic will write in a different way when addressing a different audience and no doubt the pressures of publisher and editor can be felt here.[24] There are, for instance, far fewer 'signifying practices of the bourgeoisie' and of signifiers and signifieds in general in Pollock or Clark's books published by 'mainstream' publishers than in their writing for minority, specialized journals like *Screen* or *Block*. Yet what so often marks out the new art history from the radical art history of the past is its ambiguity of stance. This usually takes the guise of 'complexity' and 'shifting meanings', falling over backward to avoid the abyss of vulgar marxism. No doubt the old-style social history of art was sometimes simplistic and methodologically crude, but such highly sophisticated circling around meaning makes the new art history read oddly like the writing of Gombrich from

whom many of its techniques of argument have undoubtedly been learned.[25]

One also finds a similar distrust for and even an inherent hostility to modernism which is quite in keeping with the traditional conservatism of the English art historical establishment. Indeed so close sometimes are the terrain, the attitudes and the judgements, that one would not be surprised to find in a few decades the leading 'new art historians' fully accepted into the art historical pantheon and honoured like Perry Anderson's 'white' refugees: Sir Timothy, Sir Charles, Dame Griselda... Not of course that there is anything wrong in a proper disrespect or doubt about modernism which the new art historians share with 'young fogey' critics of the left-right (or is it the right-left?) like Peter Fuller, Andrew Brighton and Lynda Morris. Except that it gives comfort and consolidation in a Thatcherite and Reaganite era, where there are so many who have been waiting in the woodwork and who are prepared to jump on any traditionalist bandwagon whether it is labelled 'post-modernism', 'new image', the Royal Academy, or Ruskin, Morris and Co. Yet Clark reveals more than he might have done in a more considered and hedged-around written statement, in a symposium at the Vancouver Conference on Modernism in 1981: 'There is nothing dafter than all this stuff about modernism going away. Modernism is our resource. We may have problems with it. We may in some sense be, or feel ourselves to be moving towards the outside of it, but it's our resource. We cannot do without it. We are not somewhere else.'[26]

The new art historian's definition of modernism is if anything even less clear than that encountered in the old art history. In the introduction to *The Painting of Modern Life* Clark writes that: ' "Modernism", finally, is used here in the customary, somewhat muddled way. Something decisive happened in the history of art around Manet which set painting and the other arts upon a new course. Perhaps the change can be described as a kind of scepticism, or at least unsureness, as to the nature of representation in art.'[27] This is not merely muddled, but also vague, and by the end of the book we're not

really any clearer. And in 'Modernism and Modern Art' course material, published by the Open University and largely written by new art historians, there is a constant confusion between an equally vaguely defined modernist practice and modernist criticism, which are frequently collapsed into each other.[28] It is in the material for this course that Greenberg makes his most frequent appearance, not only in the written texts and set books, but large as life, swigging generous tumblers of whisky on the television screen, chucklingly wryly as well he might, having dominated American art criticism and the modern art market since the last war and now dominating, by proxy, the new art history. For as I have already suggested, it is Greenberg the critic who has been the touchstone, the wicked fairy godfather of the new art history, interviewed by Charles Harrison in *Art Monthly* and genially debating with Clark amidst much mutual back-scratching at the 1981 Vancouver Conference on Modernism.[29]

To genuinely renew itself art history will have to look to different models from these. Some good practical work has been done – mainly by the feminist wing – but much more remains to do. The tradition of Antal and Klingender needs to be looked at critically once more, and a more radical tradition of art criticism than that represented by Clement Greenberg will have to be drawn upon.

Notes

1 T.J. Clark, 'The Conditions of Artistic Creation', Times Literary Supplement, 24 May 1974, pp. 561-2.
2 A study of this intellectual tradition by Michael Podro has appeared recently, *The Critical Historians of Art*, New Haven & London 1982. Clark does not use the term 'critical history', but I believe it could be a useful one, a radical alternative to 'the new art history', although it would have to be defined in a much more rigorous way than by Podro who proposes it 'first because it suggests a parallel with literary criticism. A central interest of these historians is

that they provide the kind of attention to works of visual art – to paintings, prints or buildings – which corresponds in certain ways to the "practical criticism" of literature.' (Introduction, *The Critical Historians of Art,* p.xxi).

3 'I'm not interested in the social history of art as part of a cheerful diversification of the subject, taking its place alongside the other varieties – formalist, "modernist", sub-freudian, filmic, feminist, "radical", all of them hot-foot in pursuit of the New. For diversification read disintegration.' Clark, 'The Conditions of Artistic Creation', p.562. 'I am not interested in the notion of works of art "reflecting" ideologies, social relations, or history. Equally, I do not want to talk about history as "background" to the work of art – as something which is essentially absent from the work of art and its production, but which occasionally puts in an appearance...' T.J. Clark, *Image of the People: Gustave Courbet and the 1848 Revolution,* London 1973, p.10.

4 Generally by feminist art historians writing about women artists.

5 This grew out of an exhibition celebrating the Silver Jubilee of the Amalgamated Engineering Union held at the Artists International Association gallery in 1945. The original edition of *Art and the Industrial Revolution* was published in 1947.

6 Elton's 'revised and extended' edition was first published by Evelyn, Adams and Mackay in 1968, reissued in paperback by Granada in 1972 with subsequent re-printings.

7 Perry Anderson, 'Components of the National Culture', in Alexander Cockburn and Robin Blackburn, eds., *Student Power,* Harmondsworth 1969, p.233

8 For extracts from Blunt's criticism see Lynda Morris, 'Realism: the Thirties argument – Blunt and the *Spectator,* 1936 to 1938.', *Art Monthly* No.35, 1980, pp.3-10. The improved newspaper and periodical criticism lasted until the late 1970s when a retrenchment to the worst journalistic standards took place.

9 This has been paralleled by the emergence of a number of younger art critics who trained as painters but who prac-

tice a purely formalistic, descriptive art criticism, published mainly in the magazine *Artscribe*.

10 *Art-Language,* vol.4, no.3, October 1978.

11 *Ways of Seeing* was first published as a book based on the television series of the same name in 1972, (John Berger, *Ways of Seeing,* Harmondsworth 1972). Sven Blomberg, Chris Fox, Michael Dibb and Richard Hollis were also credited as collaborators. It has subsequently been reprinted many times.

12 Or why it should have been even more dominant in music, where women have traditionally played second fiddle, literally and metaphorically. How many women composers have been 'written out of history'?

13 Thus the new social history of art seems to owe more to American art historians like Robert L. Herbert and Theodore Reff than to Antal and Klingender.

14 T.J. Clark, *The Painting of Modern Life: Paris in the Art of Manet and his Followers,* London 1985.

15 See Griselda Pollock, 'Artists, Mythologies and Media – Genius, Madness and Art History' *Screen,* vol.21, no.3, 1980, pp.57-96.

16 Clark, *The Painting of Modern Life,* p.78 (note).

17 Gustave Caillebotte, *Les raboteurs de parquet* (*The Floorscrapers*), 1875, Musée du Louvre, Galerie du Jeu de Paume; *Les peintres en bâtiment* (*The House-painters*) 1877, Private Collection, Paris.

18 See Clark, *The Painting of Modern Life,* Chapter 4, 'A Bar at the Folies-Bergère', and Pollock, 'Artists, Mythologies and Media'.

19 see in particular, *The Painting of Modern Life,* 'Introduction' and 'Conclusion'.

20 'Those ideas and attitudes characteristic of Modernism appear to surface during the nineteenth century and to become clearly identifiable in its later half, at a time when the hereditary upper bourgeoisie appeared militantly concerned to distinguish themselves from the rising petty bourgeoisie and the nouveau riche – to make it clear, in a world in which the distinctions between aristocracy and

working class were well rehearsed, that more than one class was sandwiched between them. This literate, educated and comparatively leisured class seems to have been concerned to establish its place in history as the proper guardian of knowledge, civilisation, sensitivity and the eternal verities. The concepts of change and renewal and novelty were admitted by this class, and served to distinguish its view of history from that of the aristocracy; on the other hand it did not envisage itself as subject to *transformation* by such changes, and this served to distinguish its self-image from that of the working class.' Michael Baldwin, Charles Harrison and Mel Ramsden, 'Art history, art criticism and explanation', *Art History*, vol.4, no.4, December 1981, p.444.

21 For example the extended discussion of the café-concert and the *artiste* Thérésa in the chapter on 'A Bar at the Folies-Bergère'.

22 Griselda Pollock, *Mary Cassatt*, London 1980, p.5

23 Fred Orton and Griselda Pollock, 'Les données Bretonnantes: La Prairie de Réprésentation', *Art History*, vol.3, no.3, September 1980, p.316.

24 See Pollock, 'Artists, Mythologies and Media', pp.67-8.

25 Cf. Peter Wollen, 'Manet – Modernism and Avant-Garde', *Screen*, vol.21, no.2, 1980, p.21 : 'In some respects, Timothy Clark's approach is similar to that of E.H. Gombrich in *Art and Illusion*, a classic on the topic of realism. Gombrich sees art in terms of a consistency-seeking system, in which a homogeneous space is constructed from a set of mutually reinforcing cues. Modernism, in this interpretation, is a system in which cues are inconsistent and the spectator is either compelled to oscillate interminably between two alternative readings (cubism equals deadlock) or else is unable to reach a settled reading at all. Timothy Clark describes *Olympia* in very similar terms: 'stalemate' rather than 'deadlock' resulting from construction of the image 'in two inconsistent graphic modes'. The question which we might want to ask, but Timothy Clark rejects, is whether this inconsistency reflects a contradic-

tion.

26 T.J. Clark in 'General Panel Discussion' in *Modernism and Modernity: The Vancouver Conference Papers*, Benjamin H.D. Buchloh, Serge Guilbaut, and David Solkin, eds, Halifax, Nova Scotia 1983, p.227.

27 Clark, *The Painting of Modern Life*, p.10.

28 Open University Course 315, 'Modern Art and Modernism: Manet to Pollock'. Course material published Milton Keynes 1983 .

29 'A Conversation with Clement Greenberg', *Art Monthly* no.73, Feb.1984, pp.3-9; no.74, March 1984, pp.10-14; no.75, April 1984, pp.4-6. *Modernism and Modernity*, pp.161-194; p.265-277.

History of Art and the Undergraduate Syllabus.

Is It a Discipline and How Should We Teach It?

Marcia Pointon

Twenty years ago, anyone making a case for history of art within the university curriculum would have based their argument in all likelihood on the coherence of the humanities and the need for a visual and aesthetic education in a civilised society. Sir Kenneth Clark's television series 'Civilisation' epitomized this approach and was itself probably the major factor in the increase in applications to read history of art in the late sixties. The debate would have centred upon the issue of whether art history (the name of the discipline as opposed to history of art, what is studied) was more appropriate to graduate than to undergraduate studies and whether classics or history was the proper preparation for an art historian. The very name 'art history', a simple translation of the German *kunstgeschichte*, is symptomatic of the irresolutions and contradictions that help to create both the richness and the problematic features of the discipline. Writing in the second number of *Art History*, the journal of the Association of Art Historians, the editor John Onians observed that 'somehow both words, "art" and "history" have a magnificence and potency about them when thought of separately which sadly they lose as soon as they are coupled in the bed of "art history";

which certainly suggests that we are not living them to the full'.[1]

In the 1980s the discussion takes place within an arena characterized by three major and partially conflicting problematics. The first of these is government cuts in the higher education sector and particularly the demands of the University Grants Committee and National Advisory Board which effectively require institutions to prioritize disciplines, modes of study and educational establishments and to forecast educational needs within assumed economic patterns of resource and demand. The second problematic concerns the changing parameters of the discipline as a result firstly of the impact of theoretical debates within other related disciplines and secondly of the rapid development of film studies, design history, media studies and so on. These developments represent within the institutional structure the widening gap between state-supported art, that which is 'centrally bound up with forms of morality and appeals to spiritual values and sensitivity'[2] and radical or popular forms of culture. The third problematic is related to the changing power structure within the discipline and the changing class profile of teachers and students. Connected with this is the reduction in employment opportunities for graduates in all disciplines. Art history is no longer exclusively or even mainly male, upper class, middle-aged and conservative, let alone Tory. There have been many more women students than men for a long time and in the teaching profession the ratio of women to men is now less unfavourable than in other humanities disciplines, bearing in mind that only 18% of university teachers overall are women. It would seem ludicrously narrow today even to suggest that one answer to the question 'What do we refer to when we use the word art history?' might be 'What is done and taught at the Courtauld Institute'. A private fortune is no longer a prerequisite for being an art historian and the days when history of art departments were associated with the best-dressed debutantes on campus have happily passed. The equation between wealth, ownership and art history is well and truly resolved.

In terms of daily teaching (and I refer to universities because I have direct experience of these, though most of what I say must apply equally to the BA history of art and design degrees in the polytechnics) this combination of partially conflicting factors affects us in a number of different ways. It is about these excitements, challenges and frustrations that I wish to speak.

To take the first problematic, the question of recession and the cuts. Even if it were possible for day-to-day teaching in universities to continue unaffected by debates about the economy, it would be wrong to allow this to happen. It is unrealistic to expect us to spend a morning trying to answer a series of questions posed by the Universities Grants Committee and based on assumptions that are inappropriate, insidious and damaging in the long term, assumptions that education is a commodity that can be regulated like the flow of foreign cars onto the market, and then to spend the afternoon discussing with students a series of essays on art in Florence under the Medicis as though there were no connection between these two activities. State intervention in the arts and cultural imperialism in its broadest sense have to be understood historically. In this instance the particular nature of government interference in the university curriculum amounts to, among other things, effectively a form of state intervention in the arts. It is irresponsible not to encourage students within the teaching situation to make connections between the history they study and the politics of their own day. Art, its production and its consumption, has always been a political issue. It is therefore wrong to suppose that what has already been done to the Arts Council, what is presently being done at the GLC, the universities and polytechnics, what it is threatened will be done to a variety of arts centres, and what has been done to the museums and galleries administered by metropolitan boroughs, has no connection with Florence and the Medicis. Our ability to make a meaningful historical analysis depends upon our awareness of the power conflicts of the present as well as those of the past.

Art history is a many-faceted discipline. And I am happy to

use the name discipline (however unfashionable it may be to do so) even if only because it has cast off its equation of wealth-ownership art history and become a profession peopled by individuals who have to work for their living. So art history is polymathic and we have long recognized its debt to philosophy, all branches of historical analysis, literature, archaeology and other disciplines. What used to be perceived as a weakness (it was difficult to accommodate art history into a departmental system and it tended to get annexed by history or fine art) should now be acknowledged as a source of strength on political and academic grounds. Students, and especially parents of students, are increasingly anxious about the employment prospects of art history graduates. The climate of opinion as expressed in the Thatcherite media presents arts subjects as Mickey Mouse subjects, non-vocational and, therefore, by definition useless. Our prime responsibility as educators at this moment in time is publicly to combat this and to set out for our students reasons for rejecting this pervasive view.

The notion of 'usefulness' in relation to many subjects taught and researched in universities is a spurious one. The health of a nation, in every sense of the word, depends upon the exercise and development overall of its collective intellect and imagination as well as upon the practical application of learning and expertise in specialized areas. Development and the capacity to change in the national as well as in the personal sense depends upon self-criticism and this is fostered primarily by the so-called 'non-vocational' arts subjects.

If we do consider art history within the definitions of those in power we see a lamentable, indeed, culpable ignorance of the theoretical and applicative relationship that is the basis of some disciplines deemed non-vocational. History of art is taught in universities in this country as both a theoretical and a practical subject. It perhaps bears the same, often for the left uncomfortable, relationship to capitalist production as film studies, in the sense that the 'pure' academic objects of the discipline effectively privilege certain forms and genres and have, therefore, the capacity to affect the market. Conservation, museum curating, exhibition and arts organisation and

dealing are all functions of international business and tourism. Britain's tourist industry and its status as the centre of the world art-market derives from the standards of scholarship that are independently developed and safeguarded within the institutions of higher education which present government policies are destroying. Moreover, however much we move away from object-based art history in universities,there will always be an implicit link with the practical aspects of artistic production. Ironically we are seeing currently a wave of pride in the achievement of British design. New and effective industrial and commercial design does not just appear; it is nurtured in an historically conscious community. Devoting time in a seminar on Courbet to discussion of the state of affairs in higher education and the arts is not a misuse of tax payers' money and academic privilege. Any higher educational process in which those being taught are unable to justify their education is not worth much. The heightened awareness of historical controversy and the ability to connect their own experience with what they read in books goes beyond what is necessary for defence of the discipline and becomes a positive educational asset.

I now want to talk about the second problematic I identified, that which is to do with changes in the profile of the discipline. There has been no massive revolt in a university art history department comparable to that which occurred in the Cambridge English department over the issue of Colin MacCabe and film studies. That revolt rumbles on. That we have not experienced this kind of upheaval should not, however, be cause for complacency. The arguments have gone on, viciously in book reviews in the pages of the *Times Literary Supplement*, in polemical pieces in magazines like *Block* and *Screen* and in confrontations at conferences and symposia. One result of the historical development (partially an accident of chronology and resources) that led to a concentration of conventional art history devoted to architecture, painting and sculpture (a triad that goes back to Vasari) in universities and to the development of design history, film studies and the analysis of visual mass media predominantly in polytechnics, has been to

explain the controversy about what art history should be as a conflict between universities and polytechnics. This is not the case. There are plenty of conventional 'development of Western art' courses being taught in polytechnics, using texts like E.H. Gombrich and H.W. Janson, and there are universities where feminism and art history, film and photography and methodology, as course material, are all on the syllabus.

Nevertheless, it is generally true to say that art historians in universities have greeted with bemused antipathy those changes through which, in English studies in particular, theory has ceased to be a peripheral option and become the central area of debate. I refer here to the intervention of linguistic theory through Althusser, Barthes and Derrida, to the anthropological and historical models established for example by Michel Foucault, the sociological theories of scholars like Janet Wolff and to psychoanalytical theories extended into the cultural zone by Lacan and other post-Freudian writers. The fact that many theoreticians foreground representation and that all are concerned in one way or another with communication as a two-way process presents a gigantic challenge as well as a great opportunity to art historians within institutions of education. But old ways die hard and most art historians went into their profession because they get pleasure from looking and have never been encouraged to consider the methodological bases of their procedures. It is not, therefore, surprising that it is being left to students to drag their teachers screaming into the 1980s.

In the old days of art history, teachers in universities would have expected or grudgingly tolerated interdisciplinary debate. This provided data for the study of subject matter, that is, iconography, and common empirical concerns such as the study of non-Western cultures or specific projects like eighteenth-century patronage. The resources of slide libraries have regularly been made available on this basis. But the ahistoricity of current methods from structuralism to psychoanalysis has sent teachers and students in search of visual material who never before set foot inside the slide library with its arrangement artist by artist, school by school,

century by century. This incursion has left art historians feeling threatened and breathless with indignation. But students of history of art don't live or work in ghettoes. They socialize with students in other disciplines and, if the facilities are offered, do courses in other departments. Some attend workshops and have access to a range of periodical literature of an interdisciplinary kind which seldom finds its way onto the shelves of the institutional library in these days of cut-backs. What they hear or read of Lévi-Strauss from anthropologists or of Saussure from linguistics students makes them ask questions about the directions of their own studies even if they are not able publicly to formulate those questions. True to the best educational traditions it is often students who, whether consciously or not, can set the pace and demand that their teacher keep up with them.

Art history as a discipline has long been in need of a more rigorous theoretical base. Indeed it is precisely the lack of theory both in the sense of a 'scheme of ideas which explains practice' and in the sense of a hypothesis in opposition to practice[4] that has often resulted in the status of art history as a discipline being brought into question. The empirical and archaeological aspect of the discipline with its strong tradition of attribution studies, that is, connoisseurship, is necessary but it has played a dominant and oppressive role and, for the rest, description and personal impression has often taken the place of serious analysis.

Although it is true that these challenges within art history come at a time when we have to meet them, as it were, with our hands tied behind our backs (our library acquisitions are restricted and our research and reading time seriously eroded) it would be foolish to fall back on this as an excuse. So how do we tackle this in the classroom? The syllabus cannot be updated by substituting one set of artists for another, one period for another though some would willingly do this, focusing a course, for example, around whichever artist or group is currently in vogue. Thus you shift the emphasis from Delacroix (a monarchist) to Courbet (a 'man of the people') and you substitute Italian Futurism for English Bloomsbury on the

assumption that somehow certain topics are more 'relevant' than others. On the other hand students have only limited time at university and if they spend it all reading theoretical texts they will be losing touch with the empirical base of the discipline. The developments of the past decade in British humanities (they go back much further on the continent) demand a complete reappraisal of how we should teach the material of art history. At the same time, the vocational requirements of the discipline outlined earlier demand that we train students who, on graduation, are familiar with major world art movements as popularly defined and are capable of distinguishing between, say, a Titian and a Tintoretto. If we don't teach them this they are disadvantaged in the employment market.

Some would say, well why bother at all with all this new theory? Well, if you see art history as a discipline devoted only to attribution studies, to establishing factual data and to describing works of art – reinvoking them in words – for the delectation of a public then it is a limited discipline indeed. Do art historians really want to be isolated within the community of scholarship at just the precise moment when everyone is recognizing the importance of visual in relation to verbal experience which, after all, is what we have been begging them to do for long enough. Although in general students welcome a methods and approaches course, in which they can stand back from the content of art history books or art books and see them as constituents within a history of art history, this falls short of an adequate solution because it leaves the main part of the learning process untouched and requires the students themselves to apply the techniques of criticism and analysis they have learnt to their study of Michelangelo or Manet.

The problem is that, given the predominantly monographic nature of the literature of art history, there is a gigantic gap to be bridged between the theoretical structure of Foucault's *History of Sexuality* and a study of the nude in painting that escapes from the essentially aesthetic trajectory of, for example, Kenneth Clark. There are several approaches that allow for a theoretical strengthening of the undergraduate syllabus

without throwing the baby out with the bath water. On the one hand, dealing with familiar images like Manet's *Olympia* or Poussin's *Et in Arcadia Ego*, it is reasonable to say forget the formalist analysis of the Roger Fry mode that is still so prevalent, albeit disguised, in art history texts, to forget the artist's chronological development and this particular picture's place in that development, to forget the Panofskian iconographical study and the treasure hunt for borrowings. Instead to look at these images, say, as a system of signs and analyse the narrative structure accordingly, or, to take nudity as an artificially constructed ideology and analyse these images on the basis of a historical theory about power, gender and sexuality. Another approach – and both are necessary I think – is to introduce a theoretical or critical text from another discipline into the reading list and to get students to try themselves to take a new look at their own discipline in the light of what they have learned in this text. Thus, for instance, Jonathan Culler's book *On Deconstruction* contains an excellent chapter 'On Women Reading'.[5] We all know from Gombrich that looking is a learned activity like reading but what Culler, drawing on a wide variety of writers and critics, establishes very cogently is the gender-directed nature of this learning process and the way in which the power structures created by that process have determined the parameters of literary debate and scholarship. Gombrich's psychology of perception, ingenious though it be, was based on work done for research seminars in the late 1950s. *Art and Illusion* ignores gender as well as ideology, and art historians can learn a great deal from Culler's text. Or, to take another example, Foucault's essay 'What is an Author?' exposes the complicated process through which individual authorship attains ascendancy in Western culture. Authorship, Foucault convincingly argues, is not a neutral concept, a natural category, but one that is constructed.[6] This has important consequences for the history of art and, by studying an essay like this, students can begin to address themselves to the historical processes whereby certain sorts of objects are privileged and others disappear from sight. They can start to think for themselves about methodology; an art histo-

rian reading this essay soon becomes aware that the principle of individual authorship and the concept of the *oeuvre* excludes collective enterprises, of which there are many in the history of art and especially of design and of media like photography. One might proceed to compare Foucault's historical discussion of authorship with Rosolato's psychoanalytic examination of paternity and the signature.[7] This need not preclude the acknowledgement of signature as a function within production.

Theory is immensely appealing to students because it can provide answers. It also has its dangers. It is no accident that the appetite for theoretical studies should manifest itself so ardently under a government which justifies its actions on the grounds of economic theory and blind faith in the face of what is experienced by large numbers of people. Theory is democratizing in that, once you have grasped the language and the concepts, you are a member of a club that is not defined by class boundaries. I am here addressing the third of the problematics I identified at the beginning. The class profile of students entering art history departments in universities has, happily, changed somewhat during the past decade. Nevertheless, within the conventional framework of art history teaching, the economically and culturally privileged student who has travelled abroad is often academically advantaged. All admissions interviewers in the subject have their own stories of the interviewee who, shown a photograph of a painting by an eighteenth-century English portrait painter and asked merely to suggest which century it might have been painted in or to say something about it, says: 'Isn't it a Hoppner? I thought so, it's so like the one in the drawing room at home'. The recent attention to theory has shifted the power centre from the unique image or object which has to be sought after, to the text which anyone can get out of the library and from there on the battle is an intellectual one. Theory can at the same time be an escape from a rigorous political analysis *and* a way of avoiding analyzing visual images and artefacts. At its best an empiricist historical method can enable us to make those vital connections to which I referred at the beginning. A

preoccupation with theory should not facilitate an escape from the empiricism that insists that the same rigorous analysis that we might apply to patronage in the Habsburg Empire or the court of Henry VIII be also applied to the way the arts are dealt with in Thatcher's Britain.

Notes

1 Art History, vol. 1, no. 2, June 1978.
2 N. Pearson, *The State and the Visual Arts*, Milton Keynes 1982.
3 Art History, vol. 1, no. 2, 1978.
4 Raymond Williams, *Keywords*, London 1976.
5 J. Culler, *On Deconstruction: Theory and Criticism after Structuralism*, 1983.
6 M. Foucault, 'What is an Author?' in ed., J.V. Harari, *Textual Strategies: Perspectives in Post Structuralist Criticism*, 1980.
7 G. Rosolato, *Essais sur le Symbolique*, Paris 1969.

This is a revised version of a talk given at the University of London Institute of Education on 10 May 1984 under the auspices of the University Centre for Teachers and published in the *Times Higher Education Supplement* on 26 October 1984. I would like to thank my students, past and present, for boldly challenging lots of my assumptions, my colleagues who read drafts of this paper and made helpful suggestions and the Sussex Literature Teaching Politics collective who listened to and discussed an early version.

Art's Histories

Adrian Rifkin

This essay starts from an assumption that one reasonable precondition of the development of a form of knowledge should be the questioning of its phenomenal representation as a form. A model for such a procedure could be found in the way that Marx questions the commodity as a fundamental form of the appearance of capitalist society in the first chapter of *Capital*, in order to reconstitute a knowledge of political economy. In art history, which is a kind of representation of history and a commodity, the linking of the words 'art' and 'history' has come about through long term processes. It is produced within the social formations that developed the modern concept of 'art', the professionalization and specialization of academic disciplines, the rise of the modern art market, and so on. But while it comes out of history, it is at the same time a denial of historicity. For art has no meaning other than the sum of its historically specific ones; and a history of art that requires a unified field of meaning therefore implies that there is no history. It would seem unlikely, then, that a new art history that really takes up this issue can long remain a history of art. But if it does not take it up, then it cannot be new.

* * *

The idea of a new art history feels stale. It suggests an anxious liberal stratagem to market a faded product in a new package. A new art history can be, and is, cut up into discretely separate portions, and each of these is consigned to its sector within a given division of intellectual work. A social history of art, a feminist or marxist history of art, a women's history of (women's) art. Or a history of the art of colonialized countries or of the confrontation of high arts and popular arts. Or a history of discourses on art, or of masterpieces re-read in the light of different kinds of philosophy, or a combination of several kinds. Piecework like this both lends itself to the dispersion of, say, feminist or marxist art histories to an individual place within a field of purely scholarly enterprise, and adapts itself to limiting the intervention of other kinds of expertise: literary, scientific or psychoanalytic. It permits the elaboration, within the already constituted domain of art history, of these philosophies and methods that, however diverse their aims and contradictions, will be adapted to its objects of knowledge. It generates new experts whose apparently voluntary eclecticism it structures and whose apparent freedom it requires.

The common element of all these new art histories is the coupling, one way round or the other, of those two words 'art' and 'history'. They remake the coupling, and it holds them together too. But whether you take it in the shape of the museum, the coffee table book, the auction house catalogue or the scholarly monograph, in forms new or old, it signals only one series of valued objects, objects whose culturally ascribed value demands that they have their own history. This is the 'series' which Walter Benjamin described as the expropriated trophies of class domination, ripped out of their production in history, represented as the natural repository of values, and demanding acquiescence that they should be recognized as such. It is to this series that new art historians put their new questions, it is this series that they try to remake as radical, or marxist or feminist or whatever. Even though they know that the series is an effect of history, they refuse to allow this knowledge to undermine their object of study. The production of

the series can be seen as part of its value, but not as its very condition of existence. In the end, when that most conservative of cultural theorists, E.H. Gombrich, insists that 'we' should always set out from the canon, more often than not radical art historians fall into line, although they might first insist that the canon gets filled out a bit.[1]

Even in a relatively new situation, such as the creation of a museum like the Musée d'Orsay where historians work on the forming of its contents, the social and cultural prestige of the series prevails. This museum is to be equipped through the transfer of accepted masterpieces from the whole of Paris, and so it is to the series that the historians address themselves. What objects should go in this museum? Should there be trolley-buses alongside the Monets, looms with the Courbets, images of workers confronting the culture of the middle class? All this to rework the history of art. But supposing it is agreed that its accepted icons are signs of something other than their own history as a series, it might then be appropriate to reverse the question. No longer what objects should go in the musuem butt instead in which museum should the objects be put?

So, to take up a type of argument which new art historians have been right to make, but to go a little further: if a painting like Picasso's *Demoiselles d'Avignon* (1907) produces its meanings only in the way in which it constructs a relation with colonialized African cultures (in its use of masks); through a fear of prostitution and venereal disease as part of a dominant discourse on women (its setting in a brothel); and the emergence of the provincial (Spanish) artist in Parisian cultural life, then, in which museum should it be put? Assuming an ideal world, in which such museums exist, should it be in the museum of colonial oppression and liberation, the museum of gender formation, or the museum of social climbing? To reposit the question in this way is perhaps banal, but at least it asks about the nature of the series-objects. It does not simply seek to give them extra meaning in their already constructed place. It is not content to merely question the inflated price tags put on paintings, nor the author's role as a marker of certainty and identity in the huge operations of international

NAH-K

patronage and finance needed to mount the one-man show or epochal exhibition. Rather, it goes a little behind these phenomena.

Although possibly leading to a romantic conception of art, a text of Jacques Derrida effects this displacement by pulling the word 'art' out of any certainty of possessing a simple meaning:

> So, if one broached the lessons on art or on the aesthetic by a question of this type (what is art?, what is the origin of art or of works of art? which is the sense of art? what does art mean/want to say?), the form of the question is already a reply. In it art would already be predetermined, or pre-understood. Already a conceptual opposition, which has traditionally served to understand art, would be at work: for example that of meaning as internal content and of the form. Under the apparent diversity of the historical forms of art, concepts of art or words which seem to translate 'art' into Greek, Latin, German etc. (but the closure of this list is already problematic) one is looking for a single and naked meaning. It would inform from within, like a content, distinguishing itself from the forms which it informs. To think art in general one thus accredits a series of oppositions (sense/form, inside/outside, content/ container, signified/signifier, represented/representer/ tative etc.) which *precisely* structures the traditional interpretation of works of art. One makes of art, in general, an object in which one can pretend to distinguish an interior sense, an *invariant*, and a multiplicity of external variations *across* which, like so many veils, one would try to see or to restore the true full sense of origin – one, naked...[2]

Taking this text to art histories can help identify firstly the way in which the series acts as the invariant of the meaning of all art history and secondly the way that though the different art histories see each other as the veil that shrouds a truer meaning for art, their real unity lies in their contestation of the object of knowledge and their common refusal to contest its

status. Even when they hotly deny an invariant value, they tend to do so by refusing it to an individual item while allowing the series to retain its status.

More often than not, these conflicts in an academic field are a sign of its renewal rather than its dispersal into new forms of knowledge. This process itself is very often a site for the representation of wider social conflict. For instance, in the general area of cultural history and theory of the last four decades and since the appearance of *The Second Sex* of Simone de Beauvoir, the most powerful social movement has been feminism, in all its diverse forms. (No doubt anti-colonial and anti-racist movements will eventually have an equivalent effect). On the whole, marxist or social or sociological histories of art have been content to contest the ownership of the interpretation of the valued series while refusing to put this structure of values under any serious threat. They have also been content to assume the underlying irreducibility of its foundations in abstract notions of quality and progress. Although some women's work has limited itself to the addition of women to the series, other more radical feminist tendencies have cut away at the residual, humanistic underpinning of the power of the series, showing that the last resort of its invariant value is not only not a resort, but a last ditch against more progressive values. This also takes issues a stage further than the way in which sociology demystifies, and ends up in neutralizing art. For it reveals the way art, in its practice and in its history, continues to be a site of conflict. A movement like radical feminism meets with a resistance which either reassigns it to a place within the piecework (a proper area of women's work), or reasserts traditional critical activities. One of these, and one of the most crucial and deceitful, is the habit of ascribing quality to defeat the logic of feminist conclusions on art. For though the ascription of quality is usually represented as an objective skill to be learned, an empirical sifting of the raw material on the basis of recognized and natural criteria, it is in fact an empty activity. While claiming to combat the reductionism of those who insist that quality is social and historical, it is in fact wholly overdetermined by the interests of finance,

social order, stability and conservatism in academic discourse. A talismanic warding off of change whose own origins and functions are repressed, ascribing quality is a hysteria of cultural production.

In relation to art history, feminism stands as an iconoclastic danger from without and a demand for the transformation of its professional relations and directions of study from within. (This is similar to its relation with a number of academic disciplines.) Here the new art history reveals its basically reactionary nature by setting out to police the boundaries of the threat of this dual collapse. The new art history can be defined as the academic enterprise which reinstates the elementary terms of the tradition from which it comes, turning political and social movements into specialisms and confounding interdisciplinary investigations by turning them back on the series-object. Looking at any sample of new art histories will show that sometimes they will 'take on' the feminist argument: but taking on is, more often than not, an option. The masterpieces stay put.

Photography also has a history made out of a series of 'masterworks', a history which is dominant in its display in museums. But the history of photography as a process (born out of and developed through industrial technologies, rapidly launched as an amateur pursuit and a tool of big business, war and the state) distances it from the aestheticized form of its representation. The existence of a magazine like *Amateur Photographer*, with its unabashed stereotyping of class, race and gender, sport, general knowledge and adventure under the signboard of the most reactionary ideologies, implies a vast social distance from any irreducible and invariant stratum of cultural value. One result of the situation is that photography has been more readily accepted as a starting point for an interdisciplinary study that, following the logic of its methods, is able to move out into a radical dismantling of social relations without having to bring these discoveries back as nothing more than meanings for the hallowed series. This difference between art and photography makes the task of dealing with art history more difficult but no less urgent. For though art

plays the stranger to photography's more overtly vulgar meanings, its intimate implication with them is hidden only by its social prestige.

But practices of art or of art history do not cease to be practised as a result of demystification. To demystify is not to exhaust a practice as a starting point for cognitive discovery nor to eliminate it as a site of social contention. The value of the artist as a human type, for example, is not used up in the understanding of its historical origins and ideological ambiguities. Though at one point the artist might look like the ideal of the thinking as well as working artisan, and at another like the model of the capitalist male who seems to produce something out of nothing, there still remains between these two a terrain for the appropriation of values. To say this is not to attribute to art the category of liberty, as does Marcuse. It is simply to insist that in a society organized around an ideology of individual freedom, any such model for this freedom is a legitimate object of desire as well as a means of social regulation. The unhealthy and reactionary glorification of technology which has come to the fore in dominant discourses on education deploys precisely this vulgar utilitarianism to dispute the freedom of choice supposedly underlying its economic basis. In these circumstances, confronted with the factitious merits of design education, art education stands in a new phase of its history. Other things apart, a new art history should have to understand this history of art. Politically, its value will depend upon how it does so.

Notes

1 E.H. Gombrich, *Art History and the Social Sciences*, Oxford 1975, p.57
2 J. Derrida, La Verité en Peinture, Paris 1978, p.26

Art History and Difference

John Tagg

Editorial Note: From 1979 to 1984, John Tagg was Tutor in Charge of the MA in the Social History of Art at the University of Leeds, a course which had begun in 1978 under Professor T.J. Clark and which was the first postgraduate degree in art history in Britain dedicated specifically to methodology and problems in the social history of art.

I came to Leeds in 1979 when Tim Clark left for Yale. I came for one year but he didn't come back, so I stayed on; five years on one year contracts without the tenure which would have guaranteed my intellectual freedom and integrity. When I arrived, the MA in the Social History of Art was one year old; in happier days, polymorphous and perverse and not yet cut by the fear of castration. It was then an informal if intense affair centred on the professorial study; a seminar of equals unworried by strictnesses of syllabus or format and untroubled by the real inequalities of educational relationships. The course now has its syllabus, structure, procedures and precedents. What it has lost by this exactness may, I suppose, have to be set against its greater frankness about the need for teaching and its openness to scrutiny. Paradoxically, the open-ended

tutorial rested on the traditional academic assumptions that the aims and objects of the discipline are given and access to enquiry is available to all. The tighter structure was the means of bringing these assumptions to view and putting them in doubt. From imagined wholeness, it produced, by the imposition of order, a fractured subject.

Five to ten years ago, it was possible to imagine a central, unified project, crucially marked by the conjunction of marxism and art history which had yet to be defined and whose consequences needed to be worked out in theory, practice and pedagogy. But that was a time when it seemed to make sense to talk of an intervention in the discipline. In the forefront were to be questions of method – questions for which, it was suggested, a solution had already been found in the born-again Social History of Art. It wasn't a matter of debate. Tim Clark wrote:

> ... I'm not interested in the social history of art as part of a cheerful diversification of the subject, taking its place alongside the other varieties – formalist, "modernist", sub-Freudian, filmic, feminist, "radical", all of them hot-foot in pursuit of the New. For diversification, read disintegration.

For Clark in 1974, the Social History of Art was 'the place where the questions have to be asked, and where they cannot be asked in the old way.'[2]

The passage I quote is notorious enough. Yet its notion of a unified method lingers on in the title of the Leeds course and is still evoked in optimistic talk about a 'new art history'. Of course the refusal to be marginalized within academic definitions of the discipline, the refusal to be accomodated and peacefully coexist as an alternative specialism, a more or less tolerated sideline, was and is correct. The point was to challenge the structuring values of the discipline itself. What does not follow from this, however, is the idea of a single methodological solution to all art history's ills, a privileged critique which will grow into a coherent practice, subsuming all other 'diversifications'. Even from the point of view of marxist

theory alone, the concept of overdetermination must imply (at least, this side of the millenial 'last instance') an accumulation of analyses corresponding to the complexly overdetermined nature of cultural production itself. These analyses have different theoretical statuses and different levels of application which cannot be ranked or put into a hierarchy in advance. Their relationships remain to be explored and explained in each historical instance but cultural history can offer no guarantees of their relative value or compatibility, let alone the reducibility of all the methods to one.

The same theoretical constraints will also frustrate hopes for an easy eclectic solution to methodological problems. Perhaps we have seen the formula 'marxism-feminism-psychoanalysis' too often to wonder at what it presumes. What strikes me is that it is the hyphens which do all the work. It may be adequate shorthand for a range of challenges within art history or for the components of a wider debate with which art history has at last been brought into contact. But its repetition has hidden tensions and incompatibilities and has implied too easily that different theoretical traditions can be not only reconciled but combined. To signal the scope of converging critiques is one thing, but to underestimate the complexity of the debate or collapse the convergence into an identity is to close down potentially productive problems and impoverish a still emerging analysis of the function of representational practices. It also means returning, against the direction of the very theoretical traditions invoked, to the metaphysical notion of a homogeneous Reality as the common referent of a number of discourses from which it may be extrapolated to serve as an index of truth.

These are not the only criticisms to be made of the once confident expectations of the Social History of Art. Too often its practice has betrayed an assumption that reconstituting art history means reconstituting the history of a given realm of objects already designated both as 'art' and as 'historical': the familiar 'masterpieces' of conventional art history. Any adequate critique of art history must, however, entail a critique of the canon or paradigm of art which it constitutes or

articulates, and therefore of the repertoire of legitimate objects with which art histories have engaged. The limits of this repertoire have, in any case, been differently drawn for different periods of study. As Kurt Forster has pointed out: 'Most museums would not, to this day, exhibit in their nineteenth century section household items, which often represent the bulk of modest collections of Greek and Roman antiquities.'[3]

Such differences have usually been settled by the economics of scarcity but it would be wrong to see the valuations of art history as merely reflecting the judgements of the market place. In so far as it operates with and defends a given definition of its objects of knowledge while limiting the permissable methods for constructing and establishing such knowledge, art history reproduces a dominant paradigm or canon of art and the fundamental values on which it rests. The paradigm appears as given but is always produced. The introduction of new methods – certain kinds of marxism, semiotics, or discourse theory – is therefore no measure of whether a radical shift has in fact taken place. As Raymond Williams has argued in relation to the field of literary studies, we have to discriminate between those tendencies which, however strange and unruly, have been compatible or even congruent with the orthodox paradigm and others which 'necessarily include the paradigm itself as a matter of analysis, rather than as a governing definition of the object of knowledge'.[4]

I should make it clear that this is not to equate art history's object of knowledge with the objects it studies. Adjustments to the latter – admitting say photography, prints, film, or advertisements – mean nothing in themselves. I could go further and say that it would be misleading to suggest that the focus of art history ought to be objects at all, where these are seen as discrete items. And this stricture applies as much against those recent attempts to see art objects as 'texts' whose 'internal' organisation must be linked in some way to certain 'external' relations. The relation of particular cultural products, particular meanings, and particular conditions of existence remains a problem which has to be studied, but particular objects can neither be seen as the expression of their conditions

of existence nor be separated from the subtle webs of discourse of which they are a part. Without denying the specificity of material practices of representation, we have to see the objects art history studies as one relation in a field of social processes made up of interchanging and mutually inflecting discourses and practices. Within this field, we must also see that the production and circulation of meanings is itself a modality of power, subject to but also generating multiple relations of domination and subordination. The question to ask is not 'What does it express?' but 'What does it do?'.

This much has been argued before. We cannot, however, leave it here, as a question of methods and objects. (What is extraordinary in Williams's response to the Cambridge debacle is that he seems to accept that we can. Though significantly, Williams's article was based on a lecture given in Cambridge University's English faculty in February 1981, at the time of the refusal of tenure to Colin MacCabe, when structuralist, semiotic and marxist approaches to literary studies became the object of public controversy.) The debate has not just lain in the realm of theory. It has been institutional and it has had a history. On this more radical level, we are going to have to understand art history as itself a cultural practice, and concern ourselves with the more awkward questions of where and when it is done, by whom and for what purposes. The questions apply to ourselves as much as to others. If the moment of the Social History of Art has retreated then one might say that Situationist Paris is a vastly different site from Harvard in the last year of Reagan's first term and neither resembles Leeds.

The roots of recent attempts to construct a Social History of Art lay in those critiques of what were called 'bourgeois disciplines' which were so integral a part of student unrest in the expanding and restructured universities and colleges of the late 1960s. For reasons that were not to remain compelling, such counter-course critiques were then entirely bound up with attempts to democratize educational structures and with that wave of diverse political movements which questioned the privileged place of higher education within the military-industrial-state complex. When Perry Anderson wrote his cri-

tique of the 'components of national culture', he pulled together the elements of a wide-ranging reassessment of academic disciplines in which art history was not ignored.[5] And yet art history never had an authentic counter-course movement. When the critique came, it came late and from teachers, even professors, rather than from students. In a changed situation, this could only heighten the dangers of academic incorporation in a decently diversified syllabus and of the containment of an oppositional discourse in closed reading groups, small circulation professional journals, and specialist post-graduate options. More than this, it shut down debate on the institutional sites of intellectual practice, rendering the new critical 'vanguard' blind to its own position within a more comprehensive system of cultural production.

The methodological debate, the critique of art history's implicit values, and the analysis of art's relation to wider processes of social reproduction went ahead. Much less, if any, attention was given to art history as an institutional practice, outside local academic politics. Few analyses were produced of the institutional sites in which art history is mobilised. Even fewer attempts were made to organize interventions within them or to establish new kinds of linkage. Equally rare were attempts to understand the effects of changing conditions of intellectual production in general: the processes of specialization, professionalization and metropolization, selective state investment, and the restructuring of education, publishing and the media, which concentrated and isolated the practice of art history like all other intellectual practices. You cannot talk of an effective intervention in the discipline which does not engage with these conditions. Yet protagonists of the Social History of Art have not seen this as their task.

Notwithstanding its links to the Left and the women's movement, the 'new art history' outside Germany has been largely a campus affair and its proponents have been, for the most part, employed academics who have been reluctant or unable to link up with curators, school teachers, guides, leisure officers, National Trust administrators, and local officials who occupy different and less privileged spaces in art history's institution-

al order. The arguments have been kept within the bounds of academic conferences, departmental meetings and learned periodicals and have been, in consequence, entirely vulnerable to a change of climate there. In Benjamin's terms, you might say that the apparatus was supplied with new material but the relations of art historical production were reproduced untransformed. When the crisis came in the universities, with budget cuts, loss of jobs, wholesale unemployment for graduates, the downgrading of arts faculties, and increasing talk of 'orthodoxy' and 'leadership', there was no effective base on which a defence of even limited advances could be made.

What followed was a number of hasty departures and domestic retreats, a flurry of accusations, and a culpable silence. The turn of the tide left some encircled and others cut off. On one side, arguments and oppositions solidified into career-tracks and publicity values, closed to all but a few elite new bloods, denigrated by a fashionable New Right, but flattered by novel attentions from older academic insititutions and new media. On the other side, the old heroics returned: accusations of incorporation and selling out; reassertions of the moral vocation of cultural and intellectual work; rallying calls for a new guerilla avant-garde on the edge of an allegedly disintegrating society. Either way, so-called 'significant culture' was seen to reside once more in the hands of a privileged or an embattled few. It was the same old play. It had been done as tragedy and as farce and had now gone into rep. But if moral denunciations, more spartan definitions of outsiderness and grotesque inflations of the role of the intellectual and artist compensated some for marginality, they could not solve problems which called for political calculation, collective organization, and institutional resistance.

This is the measure of the present impasse. It cannot be resolved by importing new methodologies, disseminating a concept of 'representation', running a course on modernism or popular culture, or by deleting 'art history' from the calendar and inserting 'cultural production'. What has to be tackled lies on a more profound level which has not yet been confronted. The confidence of ten years ago seems now in need of

its own explanatory archaeology. Clark wrote then that we stood in need of a new work of theory and practice. I might say as much now but it doesn't seem much help. No singular strategy can do anything but conceal the inherent complexities and necessary diversity of response. What emerges most strongly, however, is the need to grasp the role within the state, in its national and local manifestations, of the cultural practices and institutions of which we are a functional part. Indeed, it only makes sense to talk of a cultural intervention and struggle in relation to societies which have developed certain forms of the state and in which governmentality rests, at least in part, on the effect of a range of cultural institutions in securing the social relations on which the social formation depends. I do not wish by this to conjure up again a grand context for art history's trials. The space may be small. But modern governmentality exists in capillary forms and must be met and confronted at a multiplicity of points. Art history must know how it is touched by and touches in turn this dispersed structure of governance. But there is no neutral ground on which the attempt may be made. The problem of where to practice is as pressing as how.

Notes

1 T.J.Clark, 'The Conditions of Artistic Creation', *Times Literary Supplement,* 24 May 1974, p.562.
2 Ibid.
3 K.Forster, 'Critical History of Art, or Transfiguration of Values?', *New Literary History,* vol.3, 1972, pp.462-463
4 R.Williams, 'Marxism, Structrualism and Literary Analysis', *New Left Review,* no.129, September-October 1981, p.65.
5 P.Anderson, 'Components of the National Culture', *New Left Review,*no. 50, 1968.

This article was first published in *Block* 10, 1985.

Notes on Contributors

Dawn Ades, lecturer in the Department of History and Theory of Art at the University of Essex, has written books and articles on Dalí, Dada and Surrealism and pre-Colombian art.

Stephen Bann is Reader in Modern Cultural Studies at the University of Kent. He is the author of *The Clothing of Clio* (Cambridge 1984) and editor of 'Painting as Sign', *Word and Image*, April 1985.

Jon Bird lectures on art and design history and cultural studies at Middlesex Polytechnic and is a founder editor of *Block*.

Victor Burgin lectures on history and theory of the visual arts at the Polytechnic of Central London. His essays are collected in *The End of Art Theory* and his photo-texts in *Between*, both London 1986.

Mary Gormally is an art historian who is feminist, Catholic, married and a mother.

Tom Gretton lectures in the History of Art Department at University College London. He has written about the history of popular imagery in London in the first half of the nineteenth century and on attitudes to history in early nineteenth-century France.

Charles Harrison is Reader in Art History at the Open University. He is editor of *Art-Language* and author of *English Art and Modernism 1900-1939* (London and Indiana 1981). With Francis Frascina he edited *Modern Art and Modernism* (London and NY 1983) and with Fred Orton, *Modernism, Criticism, Realism* (London and NY 1984).

Margaret Iversen lectures at the University of Essex on the theory of art. She has written on the German tradition of art history and contemporary art theory.

Ian Jeffrey lectures at London University's Goldsmith's College and writes on art for the *London Magazine*. He is the author of *Photography: A Concise History* (London 1982) and *The British Landscape, 1920-1950* (London 1984).

Neil McWilliam lectures in art history at the University of East Anglia. He is the author of a number of articles on mid-nineteenth century France and has a particular interest in the art criticism of the period.

Lynda Nead teaches in the History of Art Department at Birkbeck College, London University. She has written on the representation

of woman in Victorian painting and on the female nude.

Pamela Gerrish Nunn is a freelance art historian specializing in women artists and in the nineteenth century. She is the editor of *Canvassing* (London 1986)

Michael O'Pray lectures on film and philosophy. He is video art columnist for *Art Monthly* and co-editor of *Afterimage*.

Paul Overy is an art critic and has written for *The Times, The Listener, Studio International* and *New Society*. He has published books on Kandinsky and De Stijl and teaches in the Department of Cultural History at the Royal College of Art.

Marcia Pointon is Reader in History of Art at the University of Sussex. She is the author of *History of Art:A Students' Handbook* (revised edition, London 1986) and *The Bonington Circle* (Brighton 1985).

Alex Potts teaches history of art at Camberwell School of Arts and Crafts. He has written on the politics of enlightenment aesthetics, early theories of the history of art and anti-modernism in architecture. He is an editor of *History Workshop Journal*.

Adrian Rifkin lectures in fine art and historical and cultural studies at Portsmouth Polytechnic and has published articles on the structures of urban culture in early nineteenth century France.

John Tagg is a visiting professor of art history at the University of California at Los Angeles. He is the editor of Max Raphael's *Proudhon, Marx, Picasso: Three Studies in the Sociology of Art* (New York and London 1980).

Frances Borzello is editor of the Camden Press art series Women on Art and Ideas on Art. She is the author of *The Artist's Model* (London 1983) and *Women Artists: A Graphic Guide (London 1986)*.

A.L.Rees lectures and writes on film studies and chairs the Arts Council's Artists' Film and Video Subcommittee.

Acknowledgements

The editors are grateful to *Screen* for allowing us to reprint Victor Burgin's essay 'Something About Photography Theory'; *The Times Higher Education Supplement* for Marcia Pointon's 'History of Art and the Undergraduate Syllabus'; *History Workshop Journal* and Routledge & Kegan Paul for Alex Potts's and Neil McWilliam's 'The Landscape of Reaction'; *Block* for John Tagg's 'Art History and Difference'. We also wish to thank Joe Darracott, Secretary of the Association of Art Historians, for his assistance.